Expression

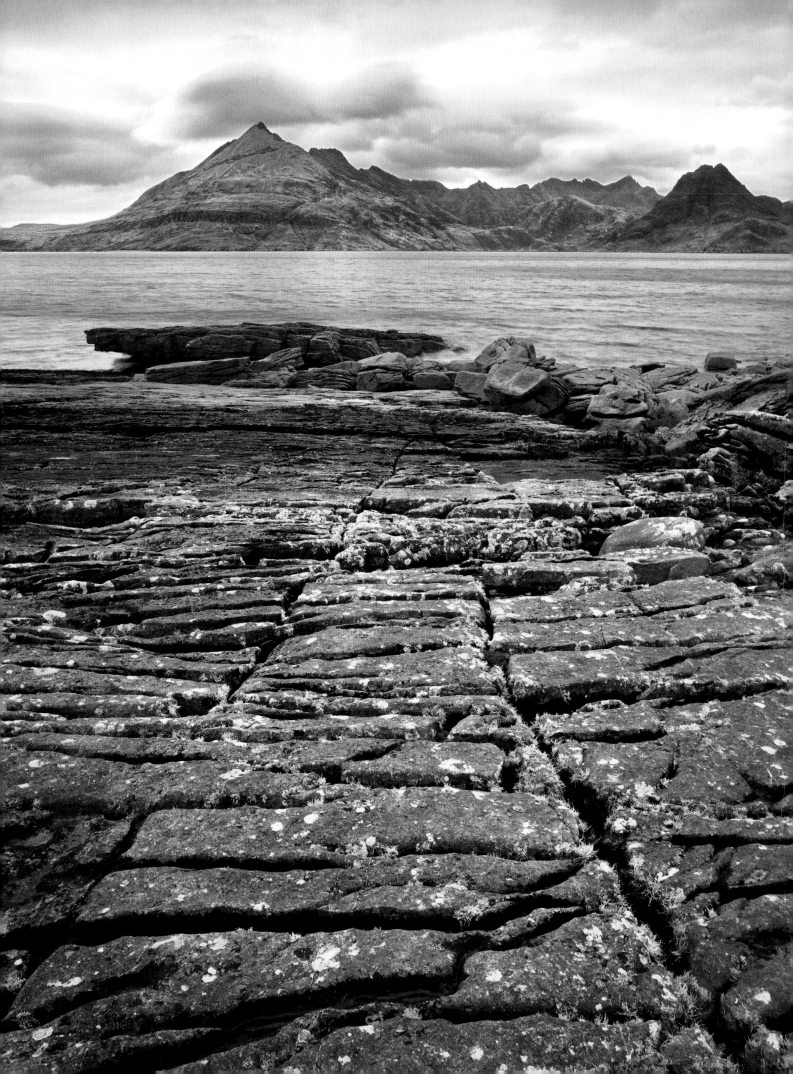

Aspects of Expression

Exploring the Art & Craft of Monochrome Photography

Paul Gallagher

ARGENTUM

First published 2008 by Argentum,
an imprint of Aurum Press Ltd
7 Greenland Street, London NW1 0ND

ISBN 978 1 902538 54 9

6	5	4	3	2	1
2013	2012	2011	2010	2009	2008

Designed by Eddie Ephraums

Printed in China

Page 2: **Elgol**
Isle of Skye, Scotland

This book is dedicated to Michelle, Ellen and Peter.

Contents

Pine plantation
Scottish Borders

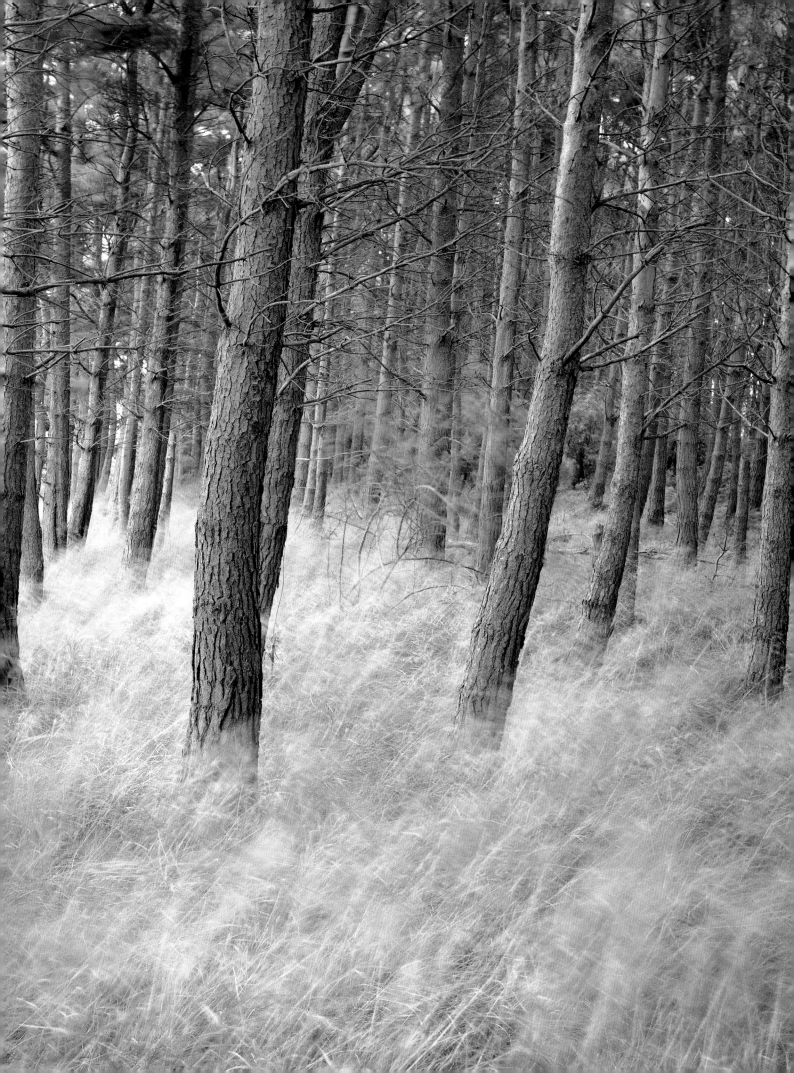

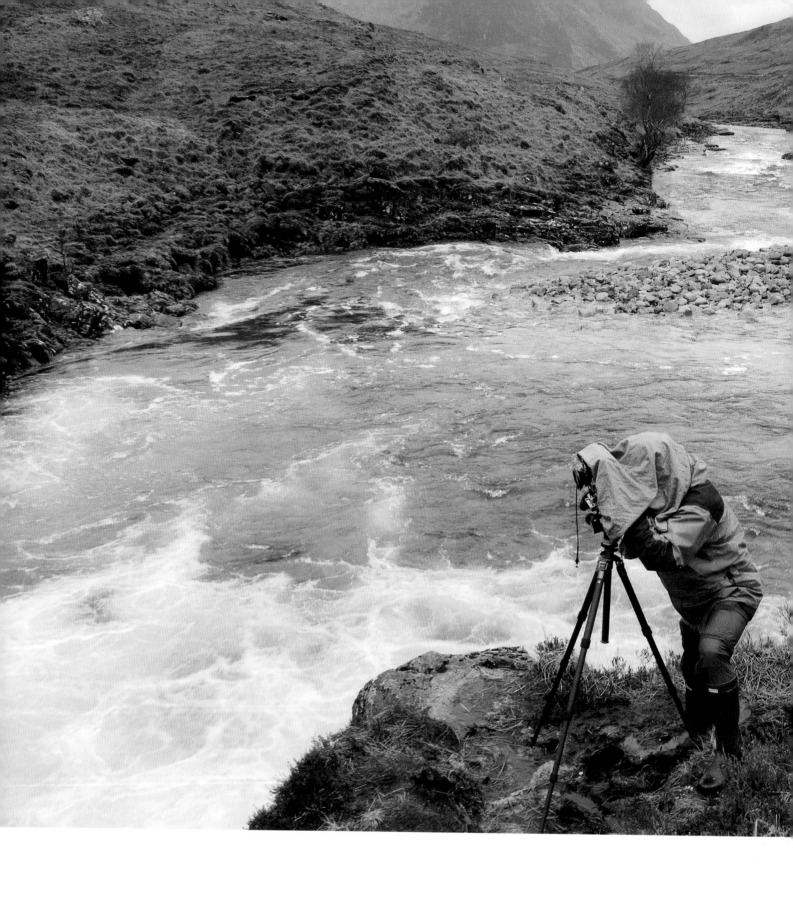

The photographer
Glen Etive, Scotland.
Photo: Eddie Ephraums

If a photograph has worked I can smell the air, feel the wind and hear my inner voice saying, 'This is the moment I need to take away with me.'

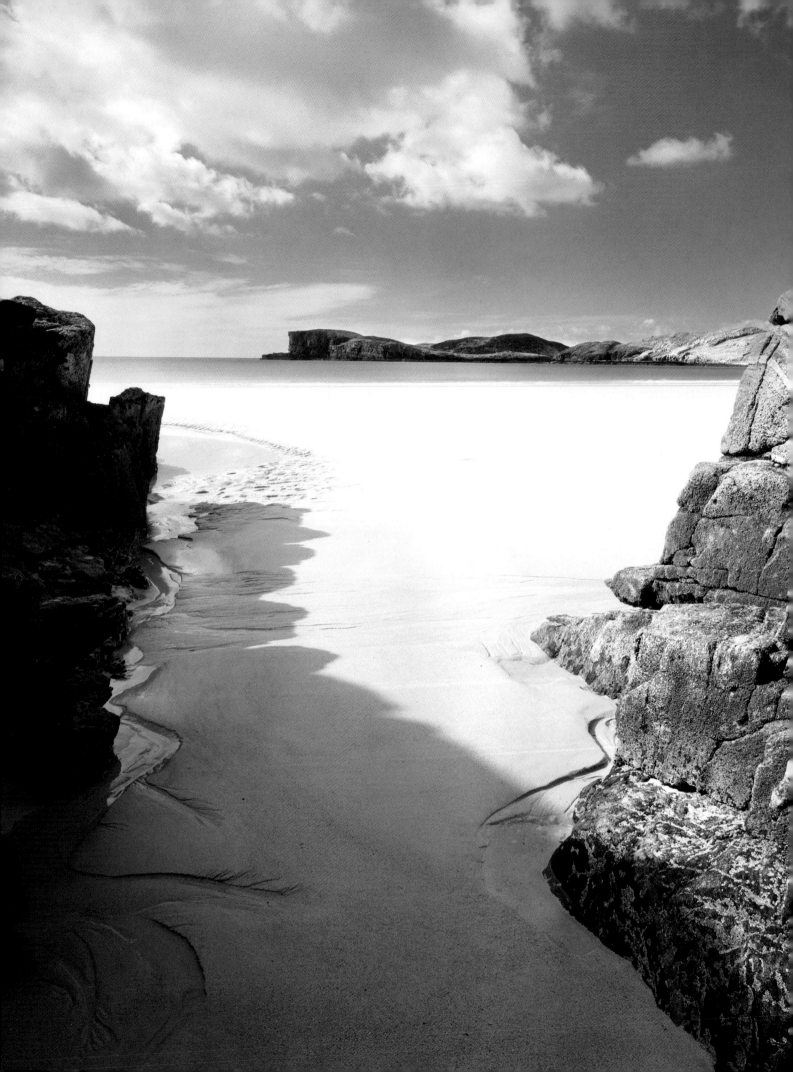

Foreword

Black and white is the mother tongue of photography, for the language of light is an ever-present theme when colour is removed. In the first century or so of photography, black and white, or what we now call 'monochrome imaging', was the only option, and it still remains the favoured form for many photographic artists and social documentary photographers. Moreover, although monochrome darkrooms are no longer a feature of most photographers' houses, the lessons that my generation learned there have informed and underpinned our vision and our understanding of light.

My first realisation of the power of landscape photography came from seeing the work of the great American masters who emerged through the f/64 Group, especially Ansel Adams and Edward Weston.

Oldshoremore
Sutherland, Scotland

In their work, landscape transcends the simple documentary facts and amounts to a revelation, an expression of the inspiration and power of the natural world formed through the vision of the photographer.

This appreciation of monochrome has never left me, and I am delighted that the traditions and potentialities of the monochrome landscape are being rediscovered and explored anew by photographers like Paul Gallagher. In the digital age new possibilities have emerged in the making of fine prints, and while the darkroom remains the traditionalist's route, Paul is now exploring the greater flexibility and extraordinary potential offered by the latest generation of inkjet printers. In spite of this, his method of image capture remains the 5 x 4 field camera and black and white negative film. While his fusion of old and new techniques really works, he does not to prescribe one approach, but illuminates all the possible workflows now available.

Being a brilliant printer has never been an end in itself, for without a good negative or digital file to work from the image will never inspire, however well printed. Paul's photographs reflect the infectious love he feels for landscape, for its detail, texture, moods and vitality. For anyone in search of wisdom and insights into the art of monochrome photography this book will appeal on many levels. They will also discover the work of a master photographer who is truly fluent in the language of light.

Joe Cornish

Moor above Wheelton
Lancashire, England

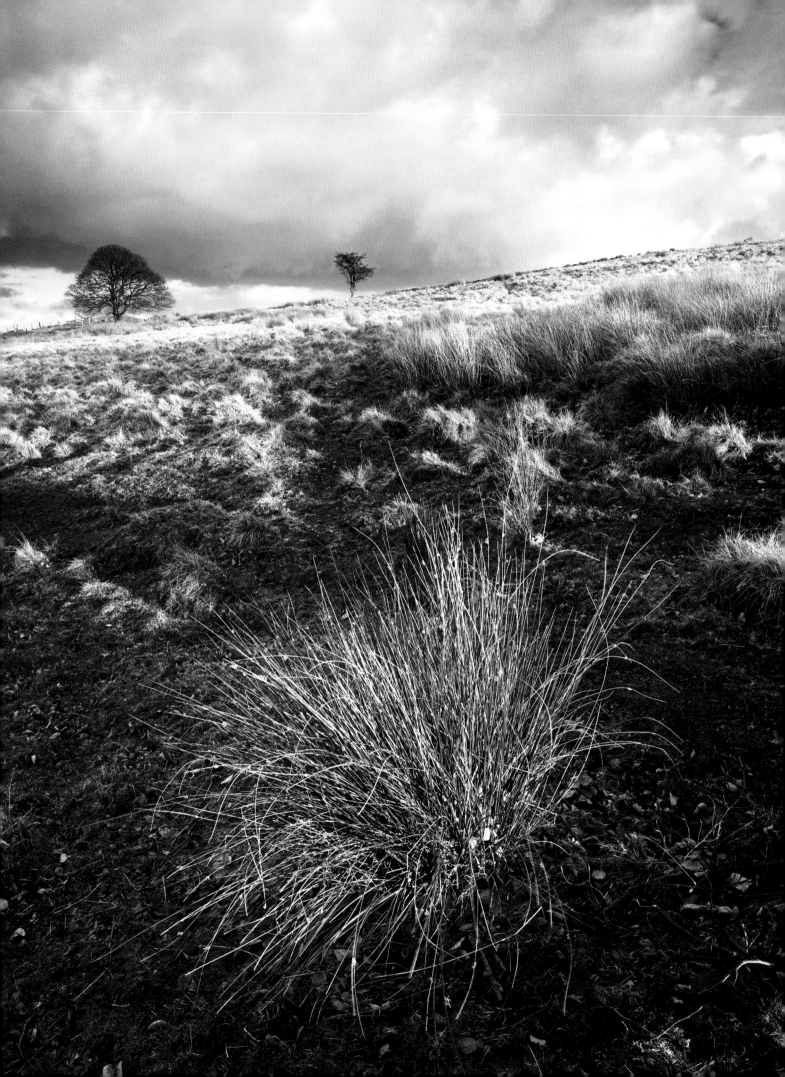

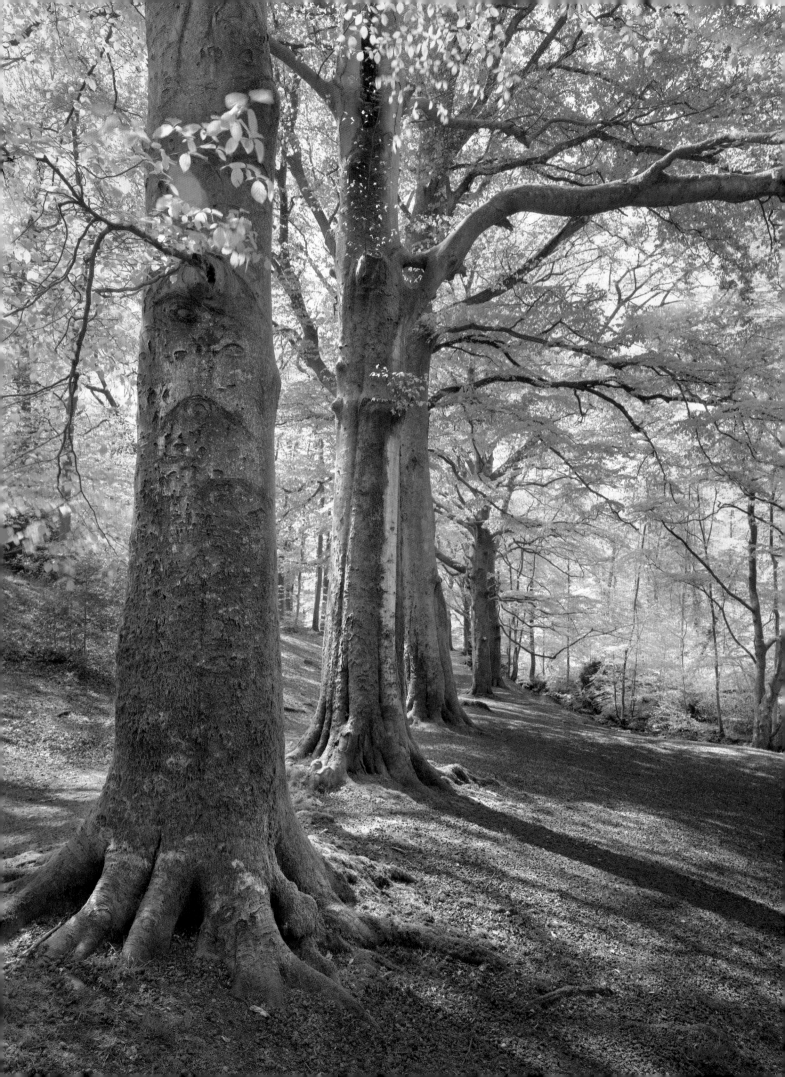

Prelude

During my childhood I had a deep-rooted emotional desire to connect with people through art. As far back as junior school, I was engrossed in drawing and painting. In a recent discussion, my mother reminded me of a set of pictures I produced at the age of nine, painted only in shades of grey. The memory re-awakened the excitement and sense of exploration that I experienced in making those pictures. I recalled being told by my teacher to go to other art classes and stand in front of the class to show them my new-found monochrome art form.

So why does this first 'monochrome' memory still have such impact? (In quiet moments I find myself soaking up the experience all over again.) I was expressing myself in the simplest way possible, and in a way that nobody had taught me. This had a profound effect on me and my teachers, yet all I did was mix black and white paint in varying amounts and allow my emotions to guide my hand – rather like making monochrome photographs, perhaps.

Sherrif's wood
Windemere, England

A similar experience occurred when I was at college. With a little more experience of life under my belt, and influenced by factors such as trends and money, I had decided that I would explore my love of self-expression through graphic design. In an age before the advent of editing software and computer design, everything was executed and fine-tuned at the drawing board, with pencils, markers and paper. I had a vision of myself emerging two years later with a portfolio of work, armed with the skills to design cars, planes and anything else that was regarded as 'cool' by a sixteen-year-old in the early 1980s. This did not happen. During the course a lecturer told us that, if we wished to understand graphics and become consummate designers, we would have to gain an understanding of photography, because utilising photographic images would be an integral part of our future careers. Thus, the projects we were given included the study of photographers and their work, something that I embarked upon with boundless enthusiasm. I recall with stark clarity the teak bookshelves of the college library being laden with a vast selection of volumes on everything from portraiture to architectural photography.

This was a time when colour was God, and I was not encouraged to seek out the work of monochrome photographers. But when I happened upon some old titles by the monochrome masters I found myself driven to return to them over and over again. I became obsessed with their images, even though my enthusiasm was not shared by my peers and such work was no longer fashionable, certainly not among graphic designers.

At college, we were given topics to discuss such as 'Images that convey vertical emphasis', and it was then that I first began to explore the idea that a photographer could convey a message to the viewer by deciding what to include in a photograph and – more

Tree stump
Yorkshire Dales, England

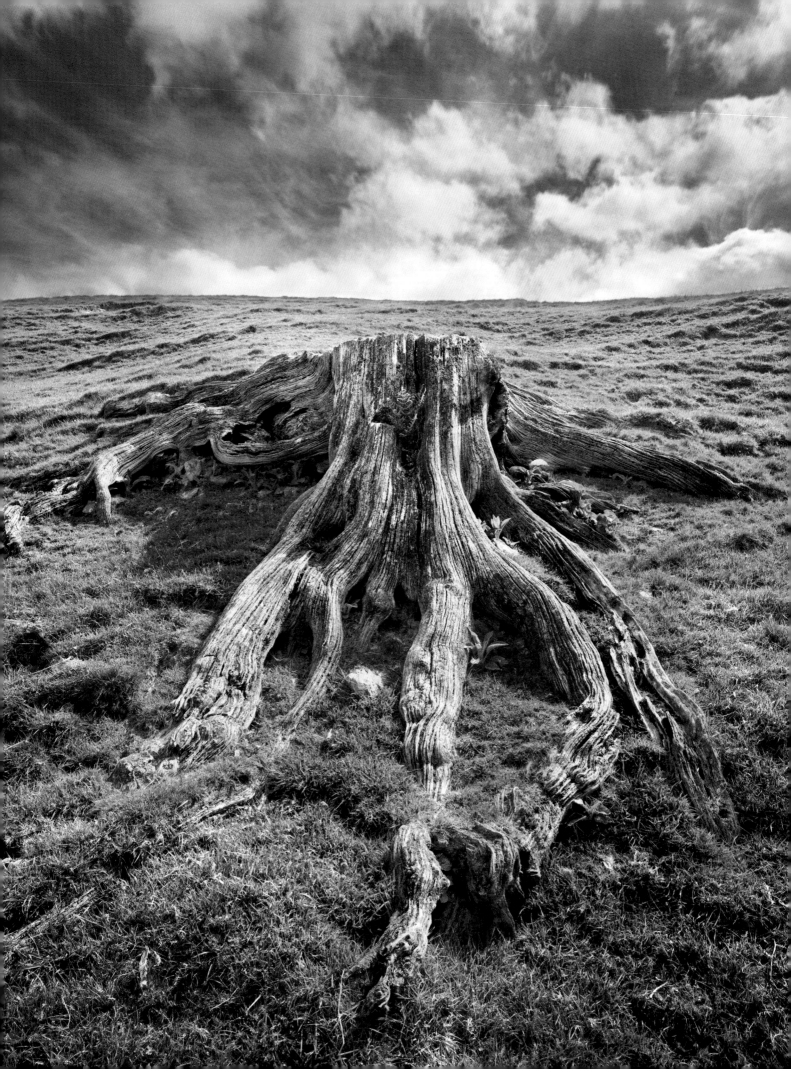

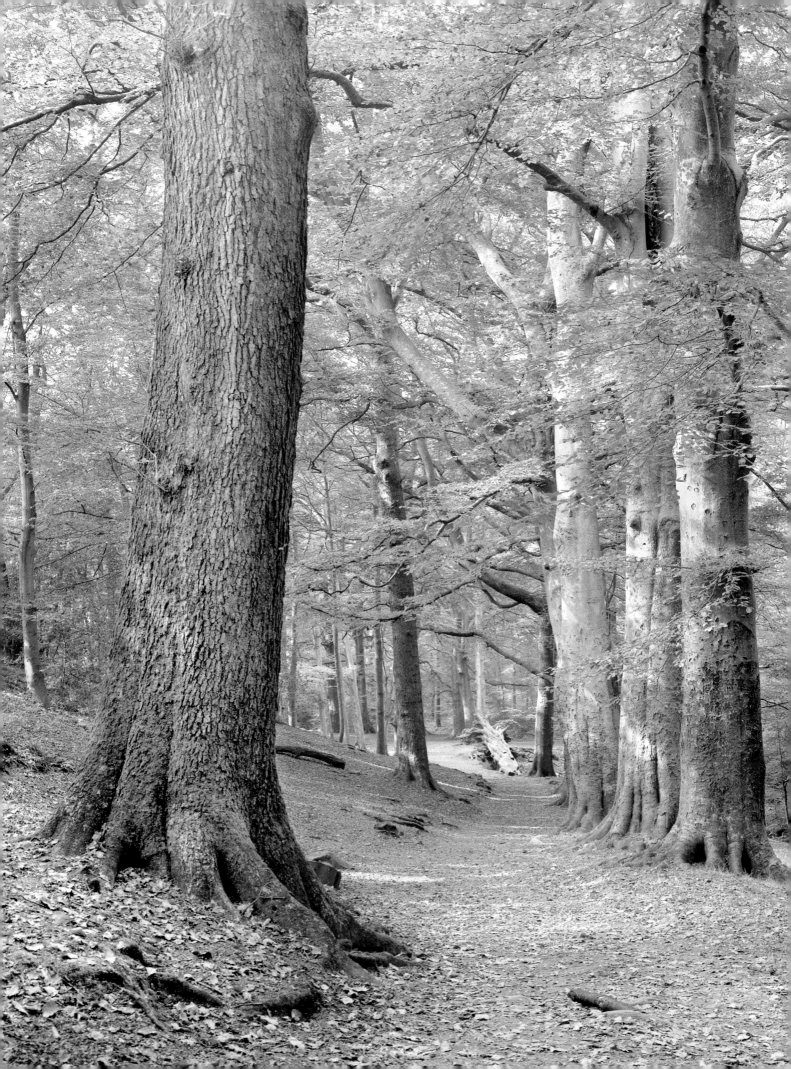

importantly – what to exclude. Few, if any, of my photographs at this time conveyed emotion, but I did acquire basic technical darkroom skills that left me feeling empowered. I also realised that anyone with a camera has the power to choose what they point it at and, ultimately, which instant of time they want to take away with them. This realisation transfixed me as I watched my first black and white print appear in a tray beneath the safelight.

With my monochrome school paintings I had made a choice. Later, there were parameters to college projects, but these served only as a perimeter fence to a playing field in which I could explore. My explorations into the expressive print began to revolve around the very tonal range that I had investigated back in my childhood.

During my time at college I became a regular and almost obsessive reader of the works of photographers such as Adams, Weston and Strand and, full of youthful energy, determined to create a print that would look like their work – full of tonalities. Of course, I never actually succeeded. I did not possess the necessary experience, expertise or discipline to do so – even if the structure of the course had allowed me the time to pursue such a goal. But these deficiencies did not quell my enthusiasm or diminish my desire to attain the same level of excellence as the masters I admired. I must have believed at the time that, given the right technique and the right equipment, I would be capable of creating photographs that would speak to me in the same way as theirs did. I believed that if I perfected my practice people who saw my photographs would understand why I had taken them. Thus I embarked upon the journey which, after many years in the darkroom refining my methods and many disappointments, I still continue today.

I am still learning and often envy the work of other photographers, both amateur and professional, and I will continue to do so. But I long

Sherrif's wood
Windemere, England

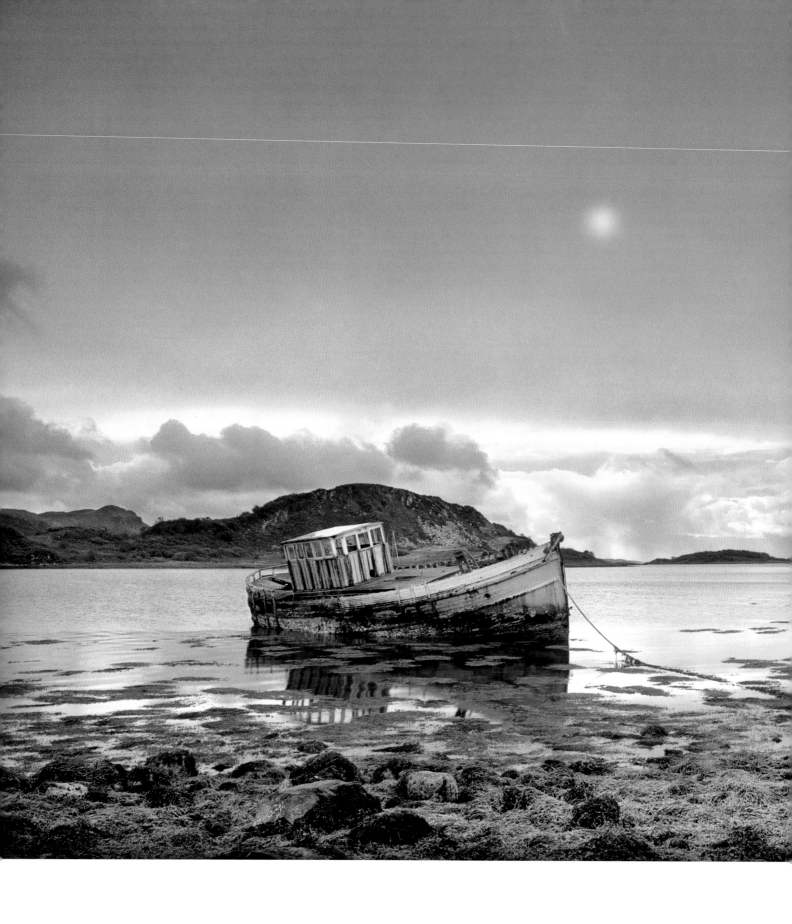

Boat at Ardfern
Argyll, Scotland

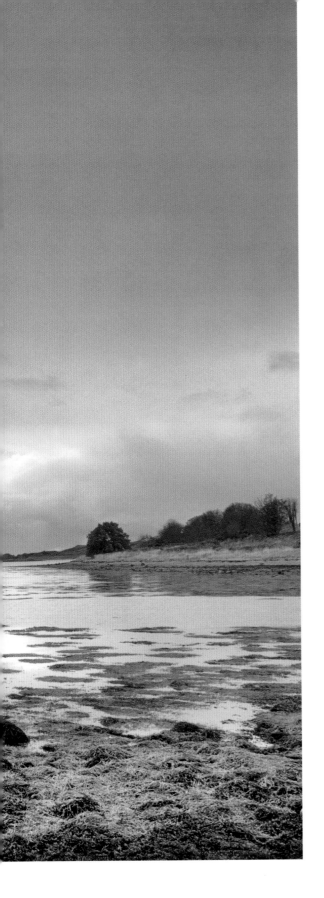

ago realised that I would never reach the end of the journey and I therefore find it surprising when I meet people who openly proclaim that they have attained their peak; their enthusiasm for photography, I find, soon withers away in the face of the tedium involved in making more and more photographs that strive for nothing more ambitious than technical competence. I sometimes feel disappointed for the photographers who enter this state. With application, it is possible to break the stalemate of complacency and take photography on to a higher plane, and the rewards of doing so are rich. Because I have always felt that my work was never complete, it is these rewards that I seek. The experience of making some of my photographs has been almost transcendental – so much so that the experience itself has become an addiction. The making of monochrome images has become my life's goal. In these pages I cannot hope to offer a definitive mantra for the making of a monochrome photograph, but I will explore issues that warrant consideration and, in doing so, I hope I will encourage the reader to delve into the world of self-expression through the making of monochrome photographs. I hope you will enjoy this journey with me.

'As with all creative work, the craft must be adequate for the demands of expression.' Ansel Adams

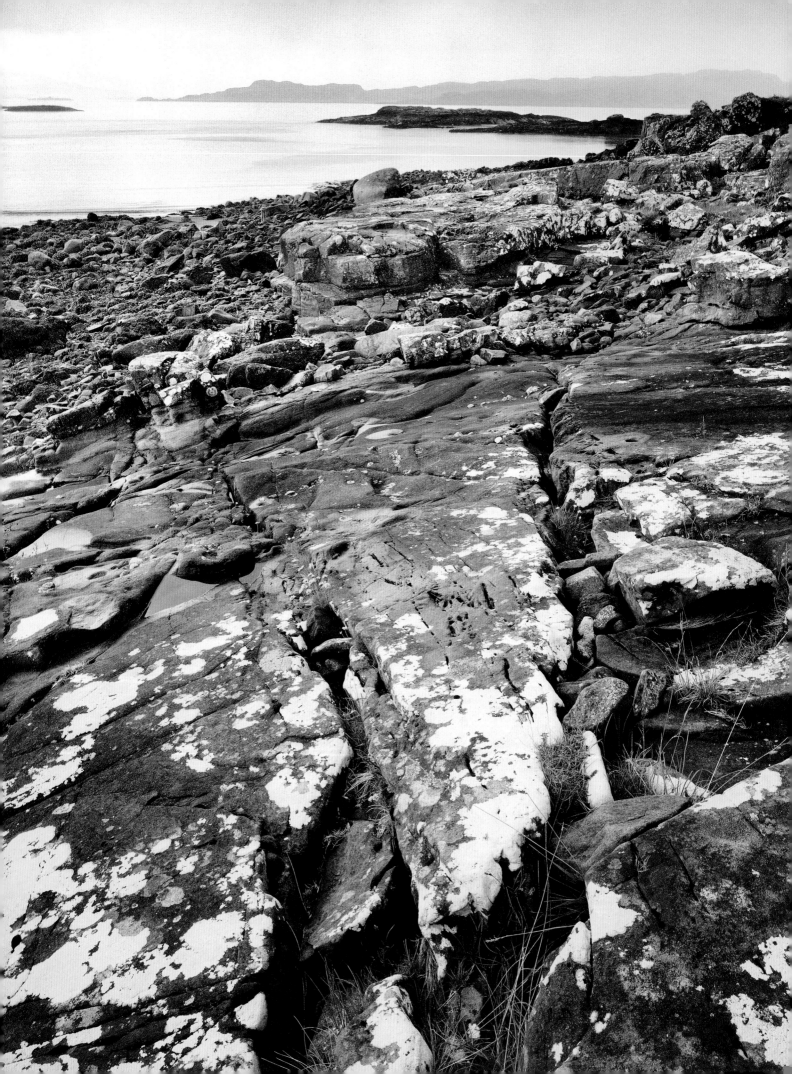

*They shout, laugh, whisper and sing
to me. My photographs. My voice.*

Light

It is often said that the best time to make landscape photographs
is just as the weather is about to change, or just after it has
changed. In my early years as a photographer I would head out in
fine weather as the sun was setting in a clear sky, and when I was
almost guaranteed no rain. After many such excursions I realised
that the resulting images did not move me at all. Although our eyes
can adjust to the sort of conditions that are typically referred to
as 'fine', a photograph records only compressed values and bright
light. The result is not the freshness and grandeur of that scene but
a shallow, two-dimensional image featuring a limited range of tones
and harsh, short shadows. A world beneath a giant flashgun!

Barrnacarry Bay
Argyll, Scotland

Photographing landscapes doesn't have to be about what's out there', but can about what is within the photographer. Light, composition and tonality can all be used to convey emotion.

Inspiration

The transient nature of light means that no two moments are ever the same. Wind, temperature, humidity, the seasons and other variables all combine to provide the photographer with an infinite number of lighting conditions. Furthermore, the time of year dictates the direction in which light falls, and its colour is affected by atmospheric conditions. Cloud cover determines the strength and quality of light, while the position and height of the sun affects how a subject is lit and the impact it has. Most photographers will have their favourite lighting conditions. Colour photographers tend to prefer the beginning or end of the day, when the quality of the light and its

Gneiss
Uig Bay, Outer Hebrides
Scotland

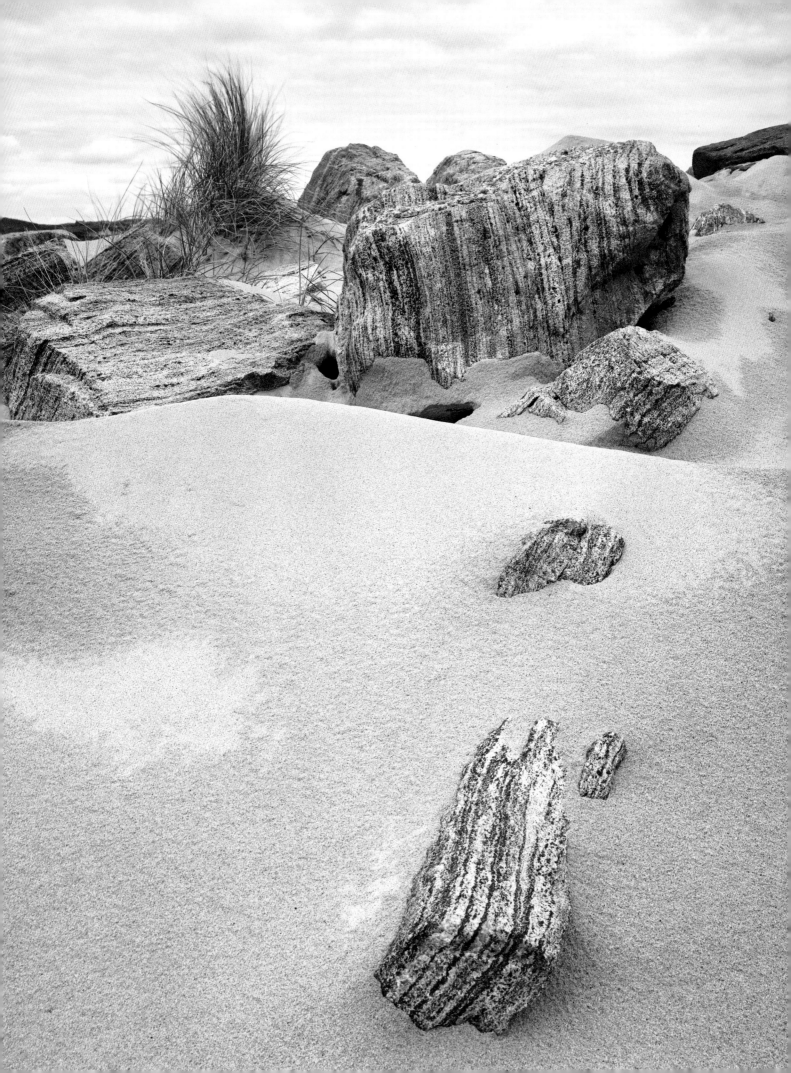

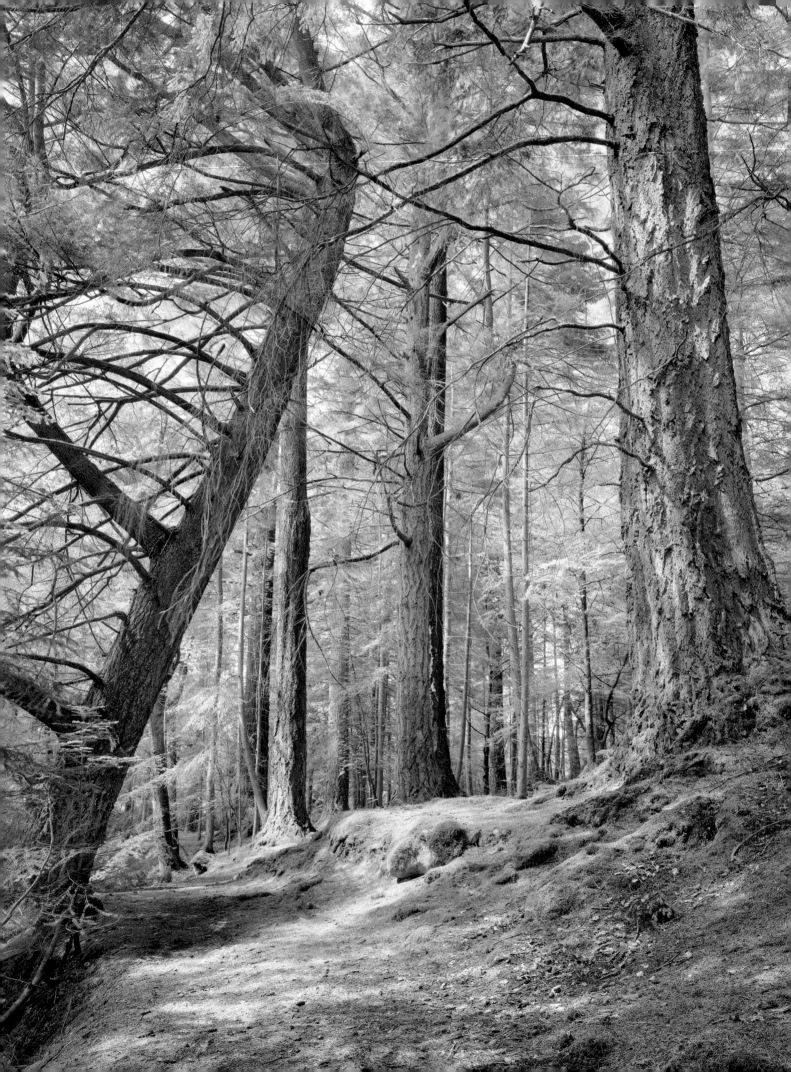

*It is important to practise the art
of composition and to learn about
depth of field and so on, but we
should be mindful of the effect of
light on composition, too.*

angle interact beautifully and form long shadows. While I, too, can be
absorbed by these conditions – particularly when there are few people
around to disturb me – I appreciate the light of a heavily overcast day
and its subtleties just as much. I have, on occasion, found myself at
the coast as a storm is brewing, the sand rendered paler in tone than
the skies above it. It's interesting that you often see as many people
out and about in these conditions as you do on a fine day, which
would suggest a certain emotional connection with the elements.

Photographers often refer to being inspired, or captivated, by light,
and it's interesting to note that the light often takes priority over the
subject. Even as I write, from my window I can see beyond a veil of
cloud a shaft of deep yellow sunlight that spears its way down the
side of my house and acts like a spotlight, picking out a single tree
at the end of my garden. It transforms the appearance of the things
I see every day, but the theatre is over in a matter of seconds.

Barcaldine Forest
Argyll, Scotland

RAW scan
The RAW scan of this Tetenal Emofin-processed negative retains a complete range of subtle tones, with full shadow and highlight detail.

Darkening mid-tones and highlights
A Curves adjustment layer was used to darken the mid-tones and bring down the highlights. Note the toe of the curve has been raised to darken – mute – the highlights.

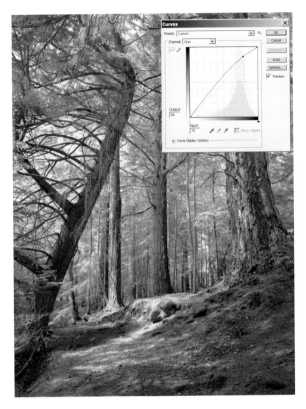

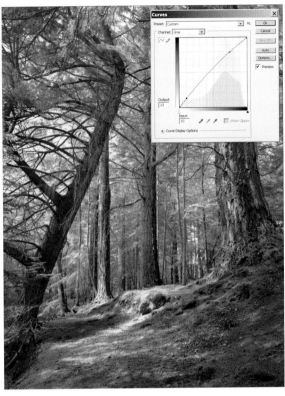

Darkening the foreground
A Lasso selection Curves adjustment layer was used to darken the foreground of the image, to help lead the eye up towards the leaf canopy.

Adding foreground contrast
Finally, another Lasso selection Curves adjustment layer was employed to darken and enrich the shadow values of the trees and leaf canopy.

Contrast range: *Care should be taken when photographing in forests, as breaks in the canopy, that form part of the composition, may be rendered as pure white, because they are likely to exceed the brightness range that the film or digital sensor can handle.*

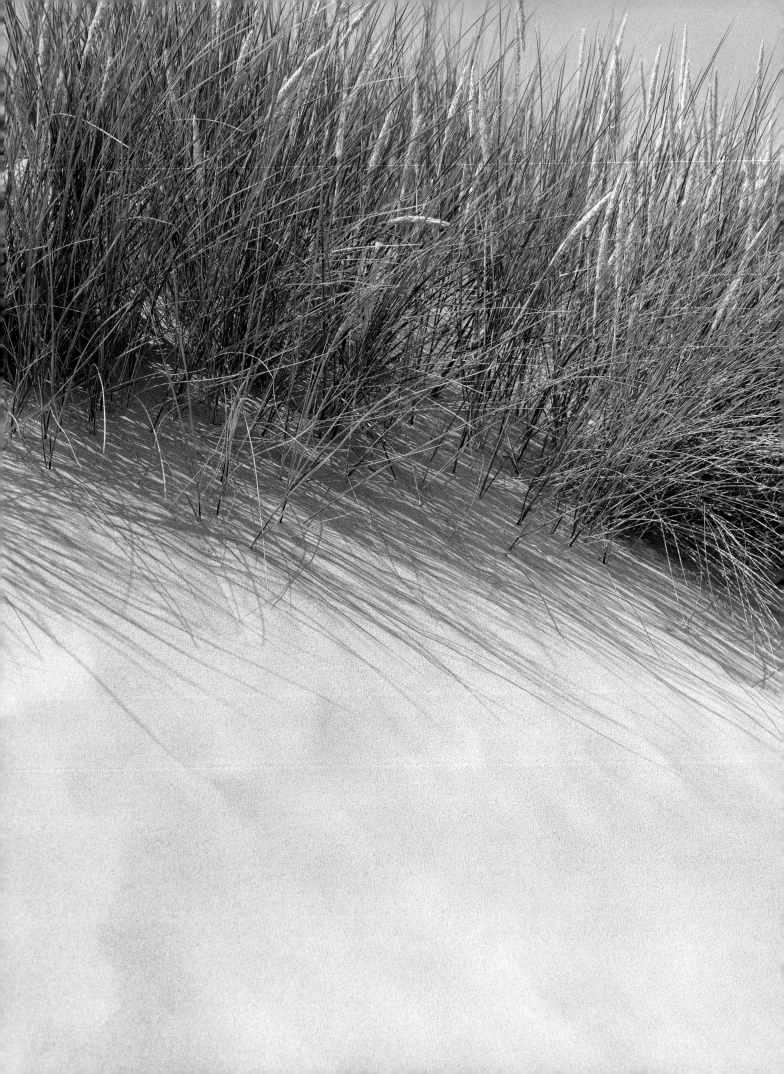

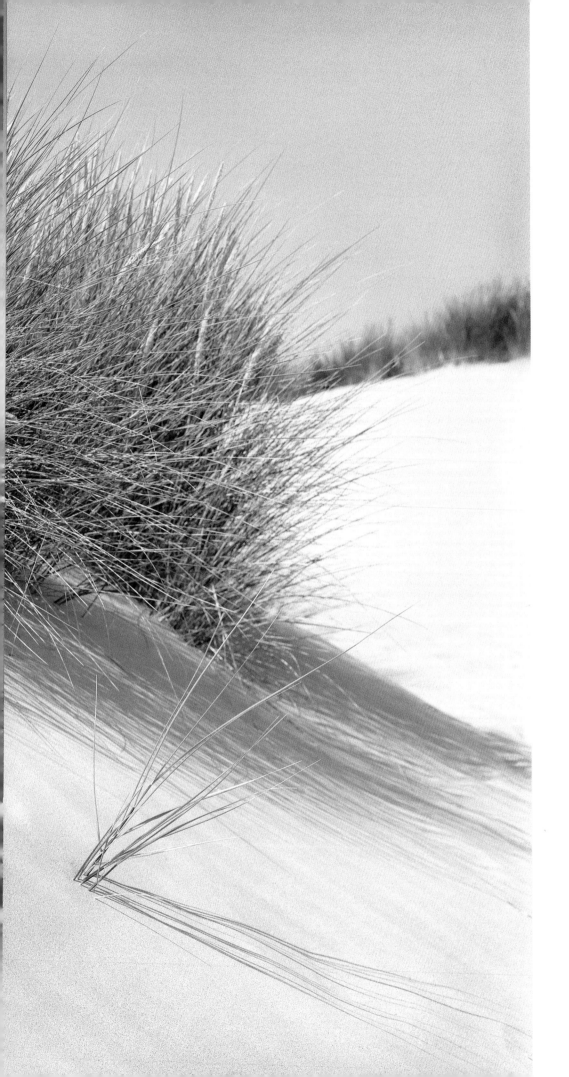

'Sometimes I do get
to places just when
God's ready to have
somebody click the
shutter.' Ansel Adams

Marram grasses
Formby, England

'I'm always mentally photographing everything as practice.' Minor White

Seeing light
The way in which humans perceive light is very different from how a piece of film, or a sensor, records it. The process of visualisation makes sense of the strength, quality and type of light we see with our eyes, and helps us understand how we can represent it in a photograph. Light is what we must learn to read, respond to and use as our tool for modelling the landscape that reflects it. As a landscape photographer, I believe that light is the indispensable basis of the photographic language. I do not aim, through my images, to simply describe the woodlands, valleys, coasts or mountains in their physical state. Instead, I use the language of light to reveal relationships between the objects that form my compositions. By representing these modulations of light as tones of grey, I intend to reflect my response to the light I experienced. In a sense, each time I press my cable release I rely on intuition and experience – and an emotional connection – to transform my visualisation into a print.

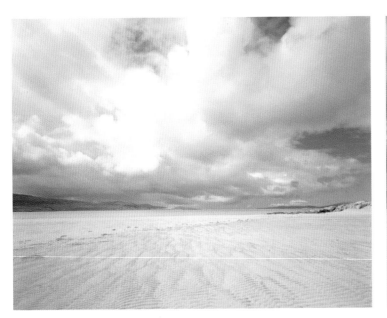

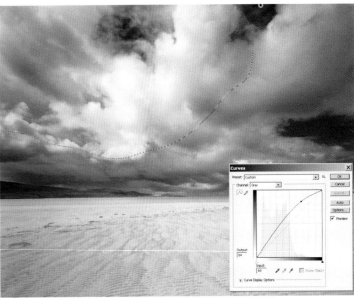

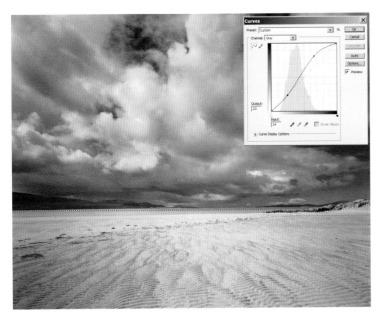

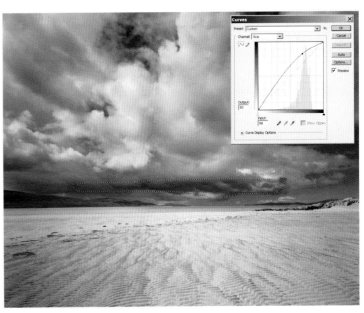

From RAW scan to finished image
The 16-bit Delta 100 RAW scan (top) had
a full range of tones with which to work,
with no blocked-up shadows or burnt-out
highlights. A Curves adjustment layer (bottom)
was used to increase the contrast of the
foreground, to accentuate the sand patterns.

Balancing the sky and foreground
First, a Curves adjustment layer was used
to make all the sky darker. Then another
(top image), was employed to balance the
weight and tonality of the sky. A final Curves
adjustment layer (bottom) was employed to
darken the distant storm and add drama to
the picture.

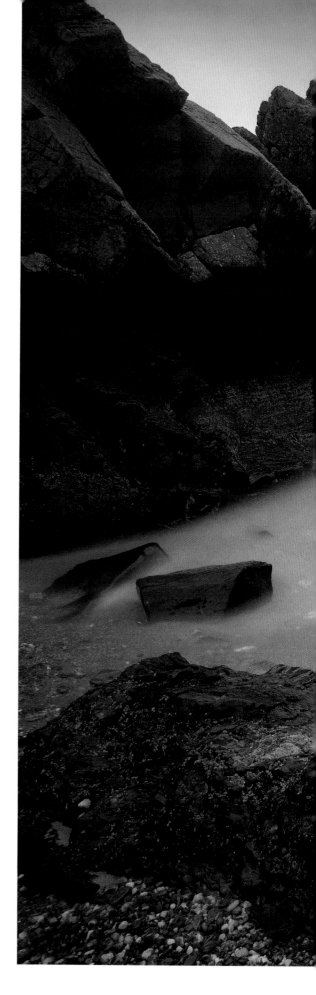

Time and light

The idea that we, as photographers, are responsible for freezing tiny slivers of time never fails to captivate me. When, with long exposures, this brief moment becomes several seconds, or even minutes, the effects can be mystical and could be defined as an accumulation of moments. We are, in effect, capturing the passing of the time, but representing it in a still image. This sort of image shows us how light alters over time, and how the composition is affected by this alteration. The advantage of monochrome films when making this type of photograph is that we don't need to be concerned about colour shifts occurring with reciprocity failure. Although long exposures can be made using colour materials, monochrome films can push the boundaries of this type of photography – exposures of up to eight hours aren't unheard of!

Skipness beach
Kintyre, Scotland

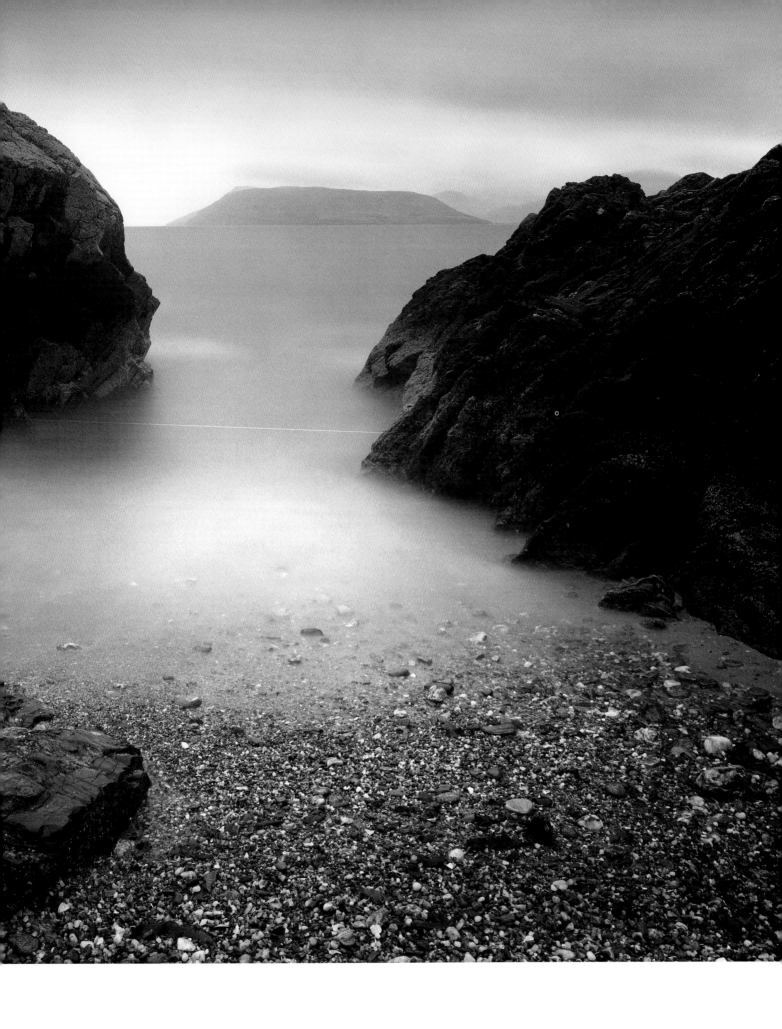

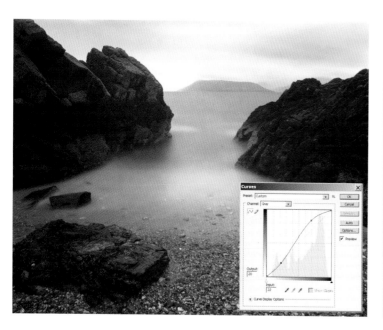

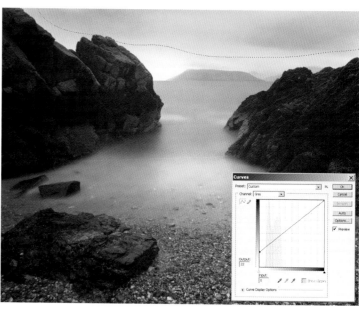

Darkening the rocks
This Curves adjustment layer was used to heavily darken the black rocks while retaining detail in the deepest shadows. The toe of the curve was pegged to maintain the highlight values.

Toning down the sky
A Lasso selection Curves adjustment layer was used to darken the lighter values of the sky proportionally more than the darker values. A straight 'curve' was used to create this effect.

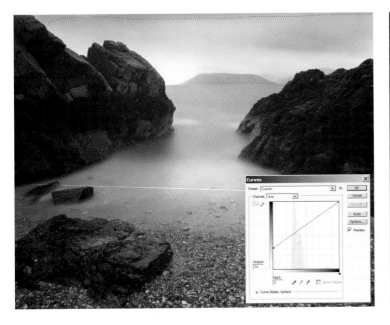

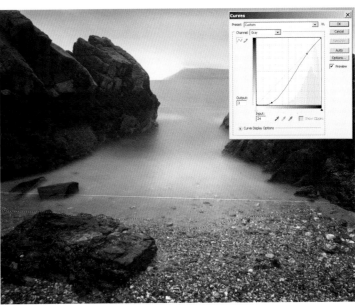

Bringing down the top edge
As for the previous Curves adjustment layer, but just the very top of the sky was adjusted.

Foreground contrast
A Lasso selection Curves adjustment layer was used to substantially increase foreground contrast, whilst being careful to retain details in the wettest, blackest rocks.

Creative boundaries: *If the moment is worth it, it's worth trying to take a photograph even if the conditions test what one would consider feasible. After all, film is relatively cheap and digital data cards can be re-used. Pushing out the boundaries can pay creative dividends.*

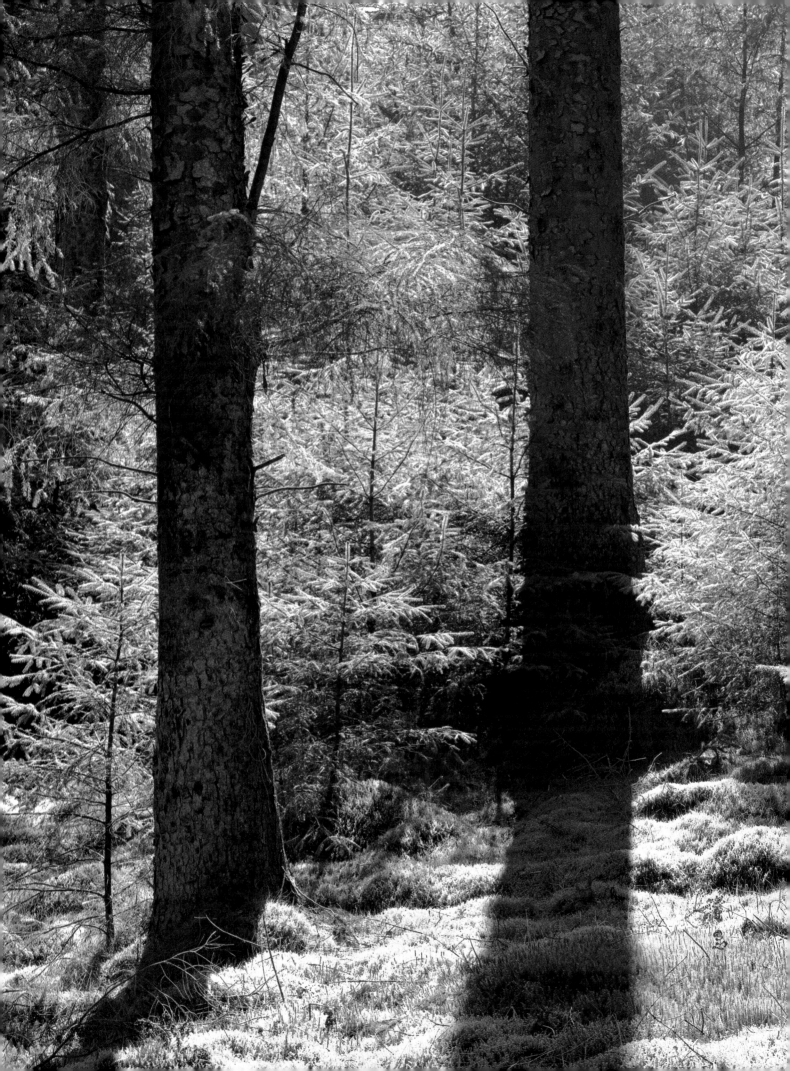

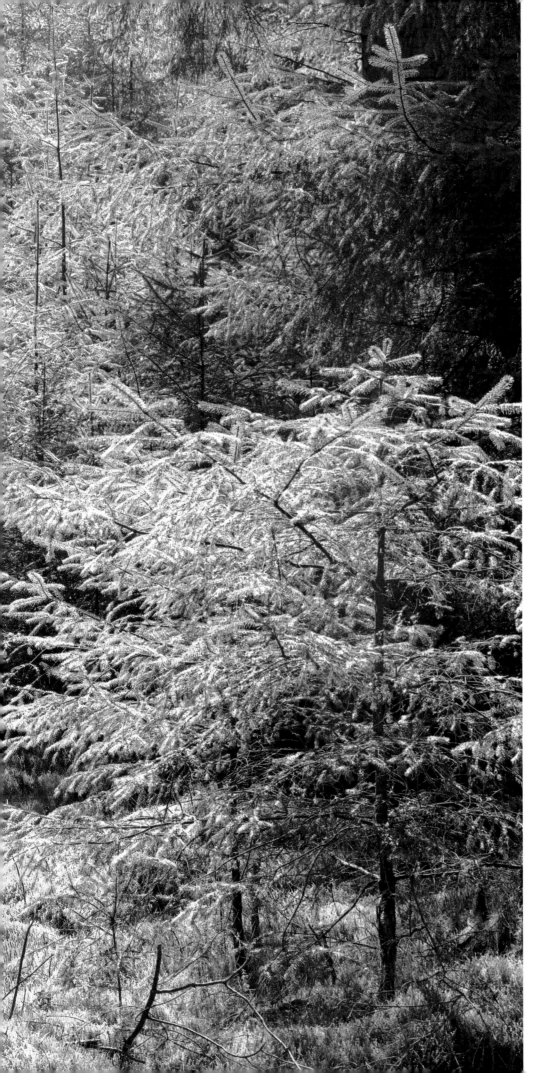

'Nothing is ever the same twice because everything is always gone forever, and yet each moment has infinite photographic possibilities.' Michael Kenna

Whinlatter Forest
Cumbria, England

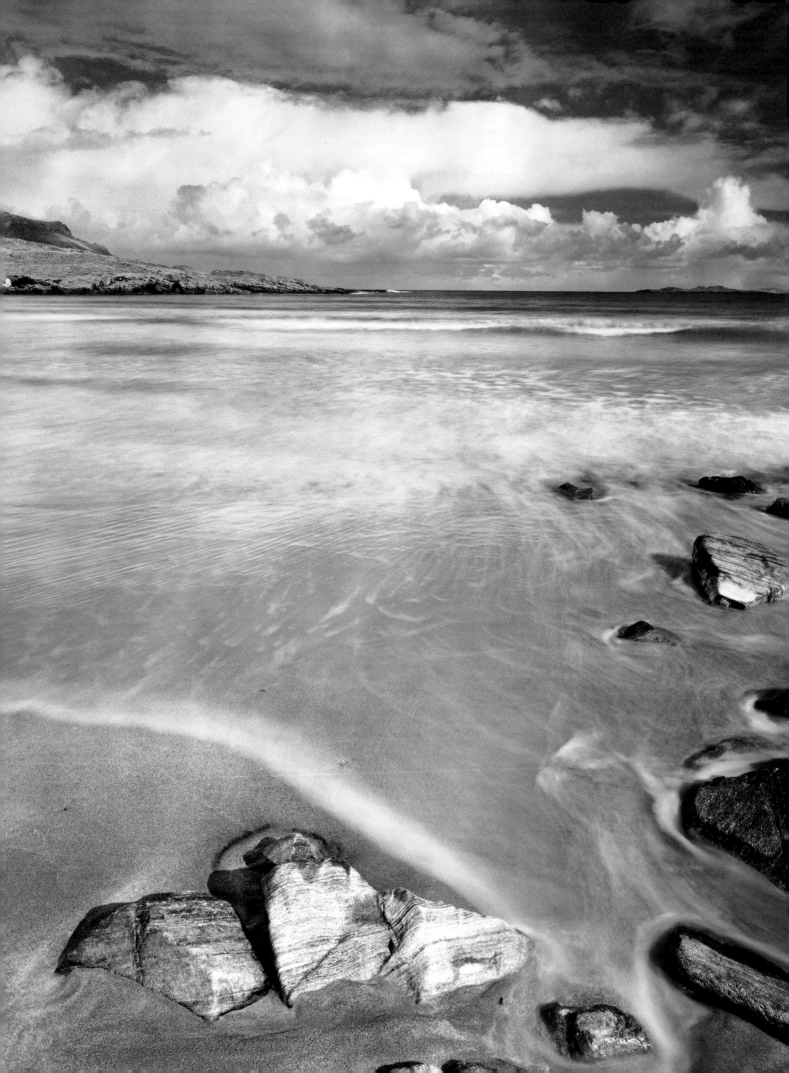

*I see little point in recording images
as a means of accumulating trophies
from my travels with a camera.*

Emotion

There are a vast number of photographic clubs and societies
throughout the world offering support and encouragement to members
dedicated to the craft of making images. I sought advice and inspiration
from such clubs and they did contribute to my development. But it was
never enough for me simply to produce an image that made my fellow
members say, 'That's a good picture,' or, 'Those lead-in lines work.' I
needed to move beyond this, because, although I was a competent
printer, I felt strangely dissatisfied with my work. This bewildered many
of my peers, who could not understand why I was being so hard on
myself, but such self-doubt is an almost obligatory rite of passage for
anyone who strives to take their chosen art-form to new heights.

Clashnessie Bay
Sutherland, Scotland

Depth in a picture can be conveyed in a number of ways – a wide-angle lens, a symmetrical composition and the use of filters to control tonality. But how do we choose to convey a depth of emotion?

Motivation I believe there are two motives which encourage photographers to pursue their art. These are, firstly, the search for the satisfaction that comes from mastering the craft and, secondly, the need to undertake a journey in quest of something that transcends technical perfection – and once the first has been achieved the second takes over.

When we are confronted by a subject, its beauty compels us to make a photograph of it, and the product of the interaction between photographer and subject has a very particular energy. This experience alone – that of capturing that evanescent moment in time – is enough to satisfy many photographers and, once the exposure is recorded, the union between photographer and subject has been consummated and the photographer moves on. There is nothing wrong with this approach. After all, artists must love their practice, first and foremost.

Clashnessie Bay
Sutherland, Scotland

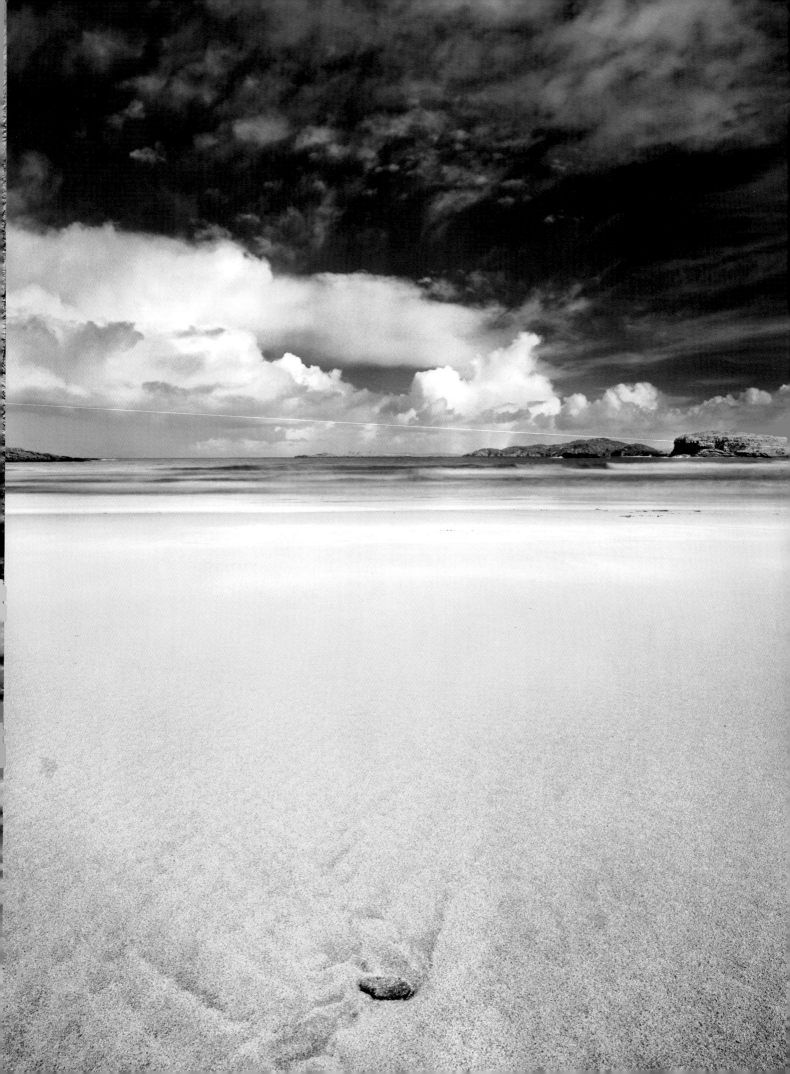

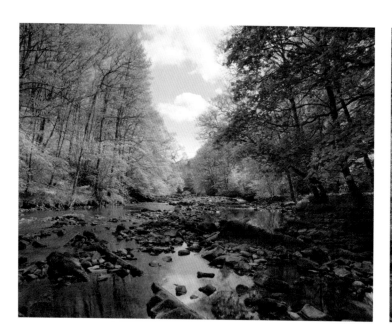

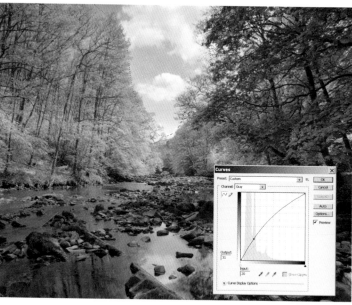

The RAW scan

It was apparent when I first saw the preview of the scanned negative in the scanner driver that this image would need little adjustment in order to achieve the result I wanted.

Darkening the sky

The initial curve was applied to a Lasso selection of the sky, to lower slightly the lighter values of the clouds. I was careful not to make this curve too extreme as it would have become obvious in the finished image.

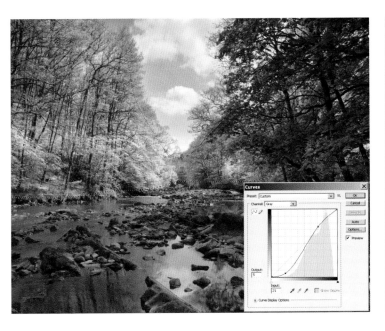

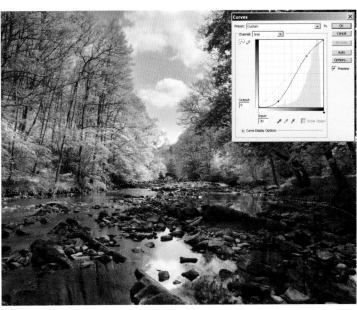

The trees and foliage

The second Lasso selection was applied to the trees and foliage and I pulled out the highlights and very slightly increased the depth of the shadows, being careful not to block them up as black.

The river and rocks

The final selection and curve was applied to the rocks and river. I substantially lightened the highlights in the water and then returned the darker end of the curve to just beyond its original position, which increased overall contrast, making the water look 'wetter'.

Practice: craft alone is not sufficient for the finished print to communicate emotion. With practice, we will reach a point where we understand the best way to communicate our message – a message that is apparent even in the negative or RAW file, prior to printing.

Printing with emotion doesn't always mean printing heavily, but when it does, the best negative and its scan, or camera digital file, usually needs to have a full range of tones from which to work, then print.

In-tune
When we make a landscape photograph, we cannot be in control of its every facet. But if the photograph is to convey emotion, we need, first and foremost, to be in tune with ourselves. It would be almost impossible to create an image that celebrates the landscape without rejoicing in it ourselves. We can, of course, if equipped with the right tools and appropriate skills, make a record of the subject with an accurate exposure and considered composition, but the result is likely to be sterile, and rather like a postcard or placemat bought from a tourist office – all blue skies and green leaves.

On returning from a trip, as I process my films and upload my digital files, I feel a sense of expectancy and excitement. And, once I start working on an image, I'm transported back to the place where I made the photograph, alone, and contemplating the next step in the process of visual communication. But what does the idea of photography as a language in which we can communicate actually mean? The technical aspects of photography are only the vocabulary – and vocabulary only makes sense when assembled correctly. Mastery of exposure meters, cameras, computers or chemistry all bring us a step closer to becoming a conversationalist in photography, but some photographers place so much emphasis on the technical aspects of their art that they come to believe that once these have been perfected they will have achieved total fluency in the language of visual expression.

Ailsa Craig
From Bennan Head, Arran
Scotland

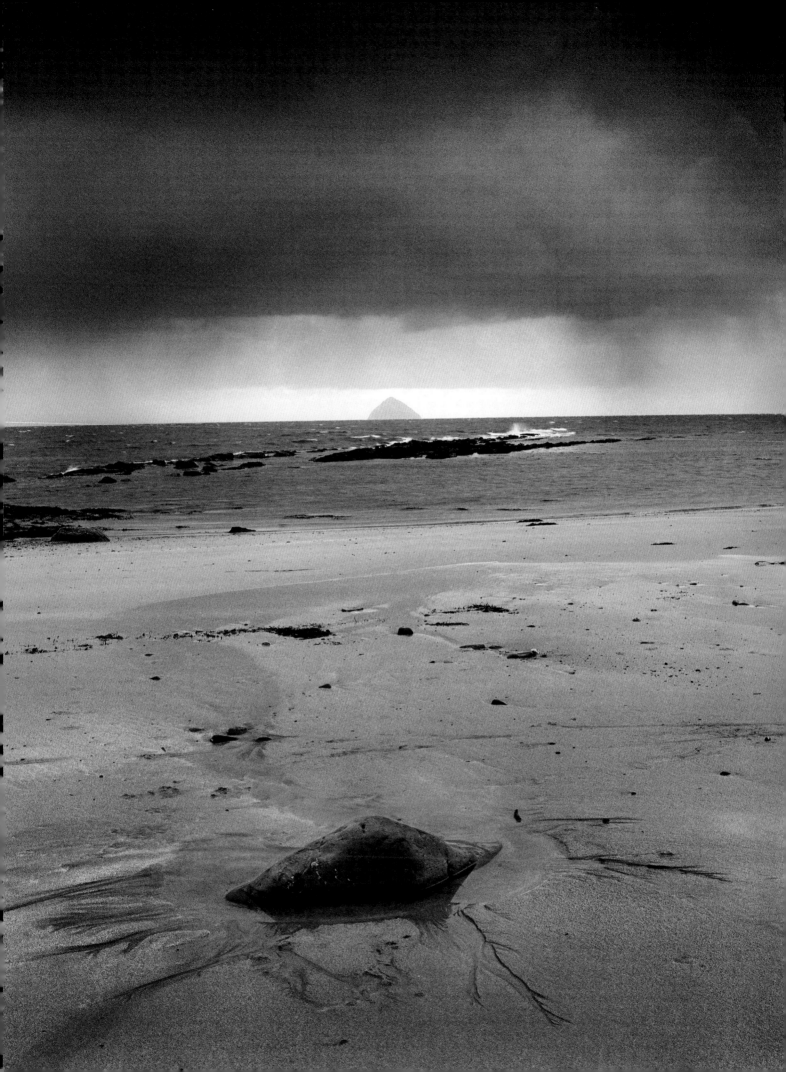

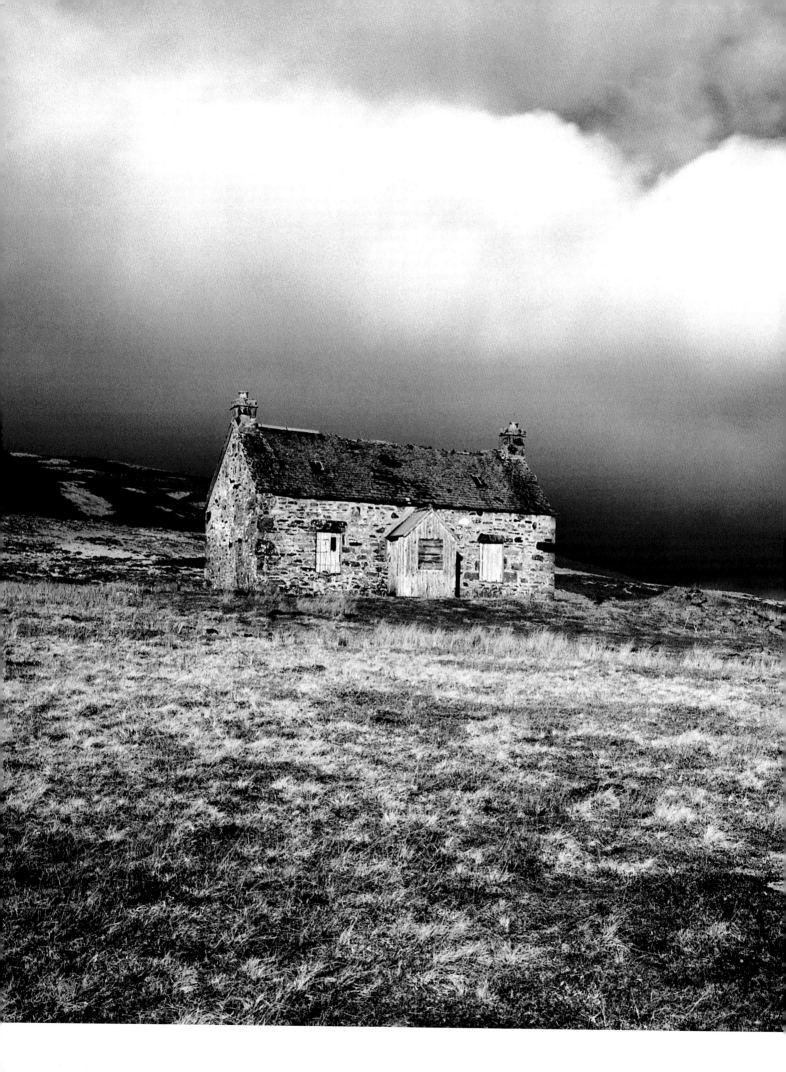

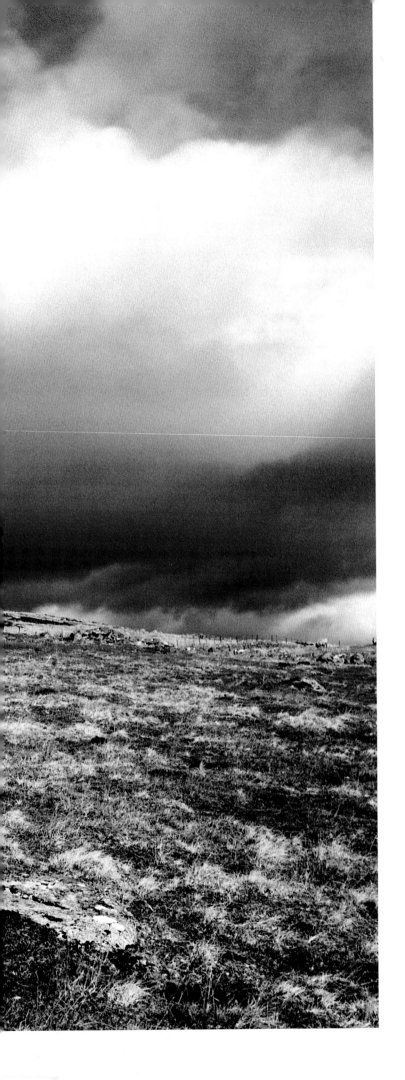

A journey

Photography, like all the visual arts, is a medium of communication. So many of us embark upon this journey because we feel we have something to communicate about our experiences. Photography is a relatively new form of artistic expression and is, to a degree, misunderstood by the arts world, which sometimes does not grasp its apparent directness and seldom appreciates its subtleties. One day, however, it will rank alongside painting and drawing. We are painting with light, after all!

Abandoned croft
Perthshire, Scotland

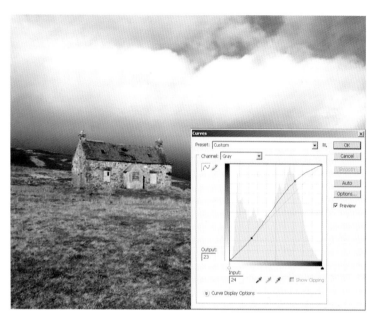

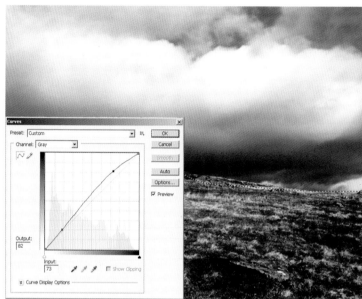

Darkening the lower storm clouds
The first curve began the process of darkening the lower storm clouds and adding the initial injection of 'mood'. After pushing the upper part of the curve I returned the lighter values back to their original position.

Darkening the sky
A Lasso selection Adjustment curve was used to darken the sky and clouds, setting the abandoned croft in its context as a lonely structure on the hillside.

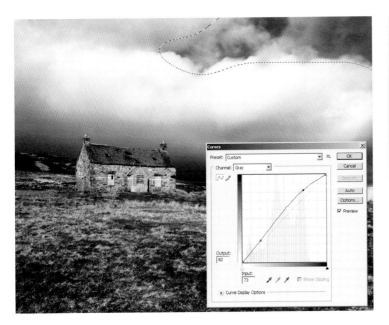

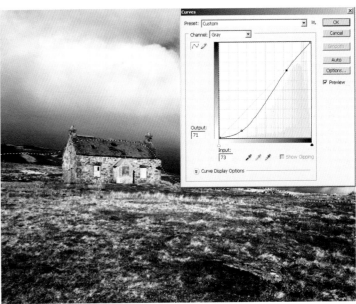

Creating depth and movement
After selecting the break in the clouds at the upper right, where blue sky appeared, an Adjustment curve was used to slightly darken this area and accentuate the clouds next to it that were moving in the strong winds.

The croft and grass
The final Lasso selection encompassed the foreground and croft and this curve pushed the contrast even further, making the abandoned croft glow in the evening light. It also picked out the white moorland grasses.

Viewpoint: It is often wise to not accept the first standpoint as ideal but to explore different viewpoints. It is equally wise to retain simplicity and have the courage to employ this in your compositions.

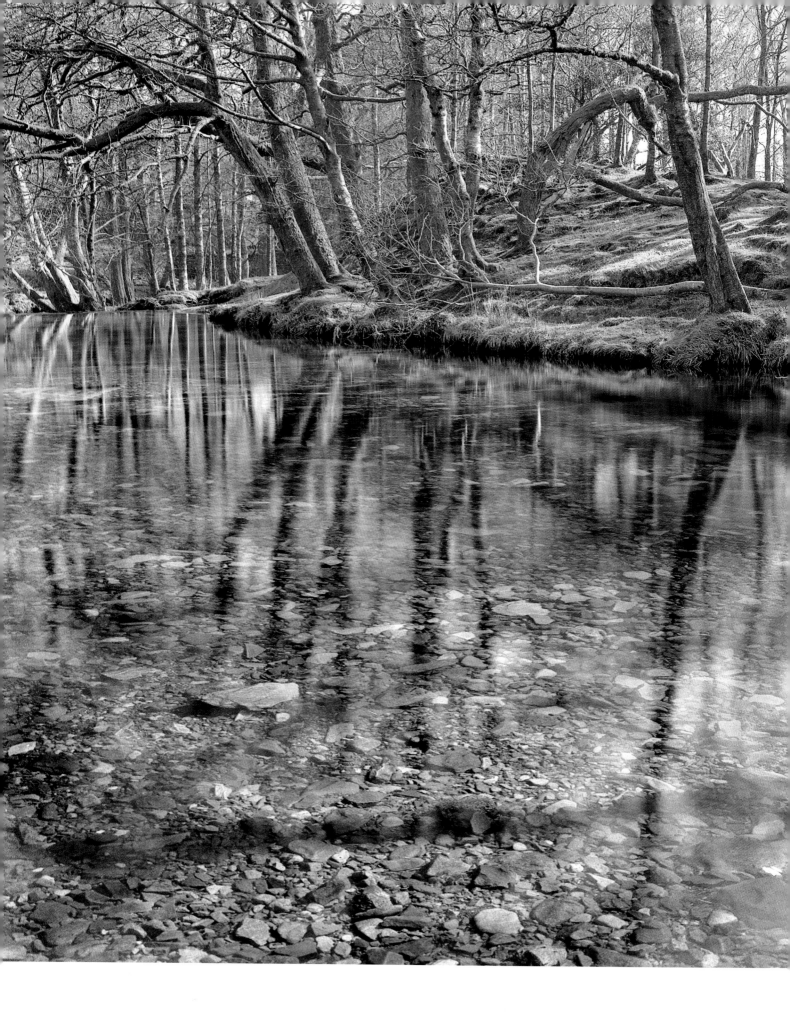

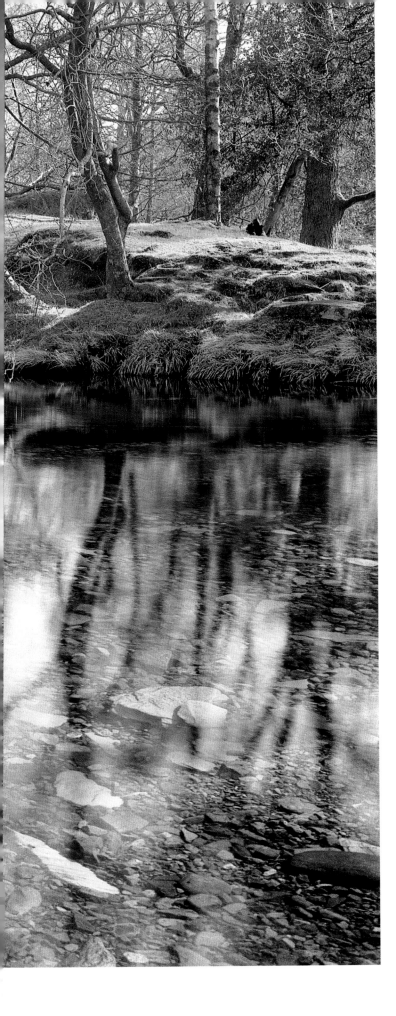

Look at the edges of the frame – not just through the centre of the viewfinder. Some compositions require the picture elements to sit within the frame, others benefit from the elements breaking out of it.

Chapel Stile
Cumbria, England

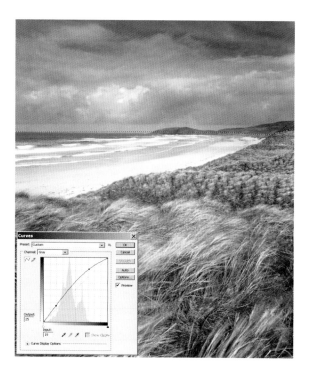

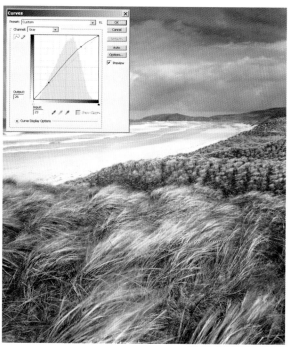

The sky
The starting point was to select the sky and slightly darken both the mid-greys and the highlights while retaining subtle tonal values.

Accentuating the grasses
The second selection with the Lasso consisted of the marram grasses in the middle distance that receded away to the higher dunes. Contrast was increased here to accentuate the sun-bleached tips of the grasses in the soft sunlight.

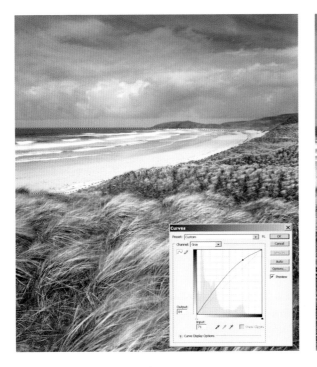
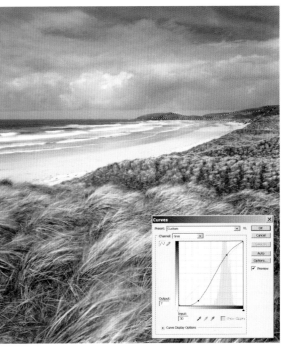

The sea and wave crests

Concentrating on the beach, I made a Lasso selection and darkened the values in the sea which brought out the wave formations as they approach the shore. This also toned down the white wave crests which where difficult to control even during exposure.

The distant headland

I recalled that when I made the camera exposure the milky sunlight picked out the distant headland landform. A final Lasso selection was made of this feature and the Adjustment curve was pulled acutely to enhance the effect of the sun.

Connect: *allow time to emotionally connect with the landscape. Even if one only has a limited amount of time to go on location, surely it is better to take time to connect with the subject, even if it means exposing fewer images.*

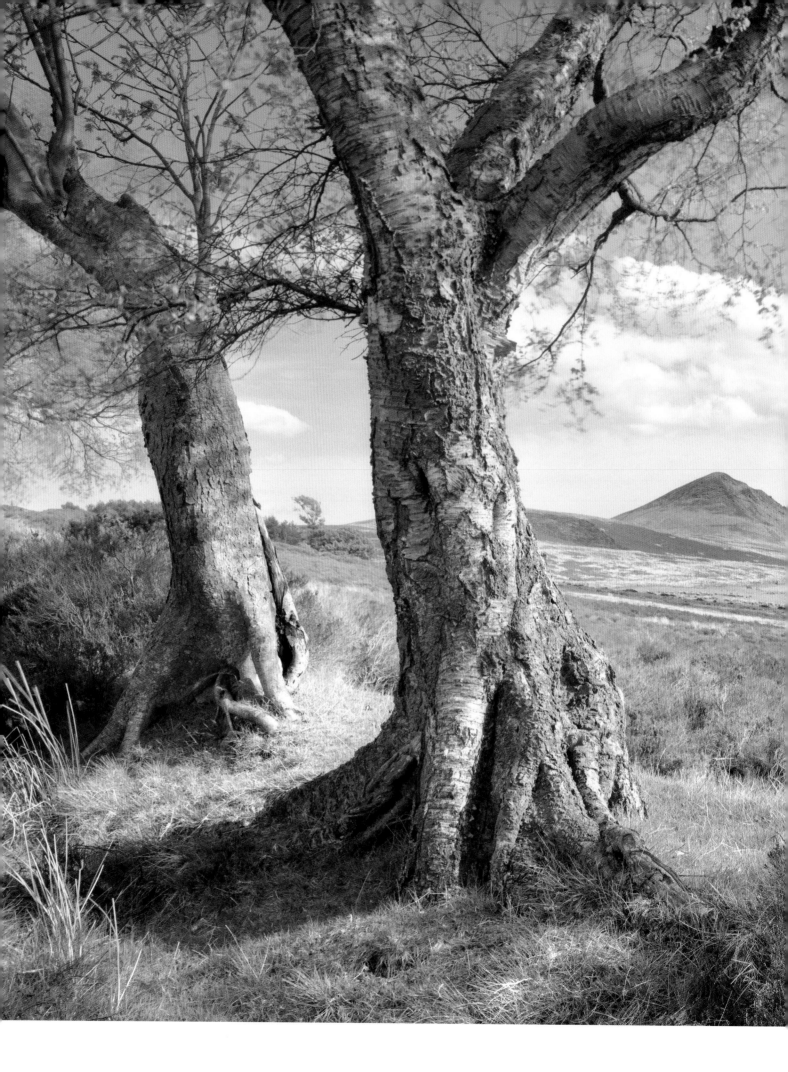

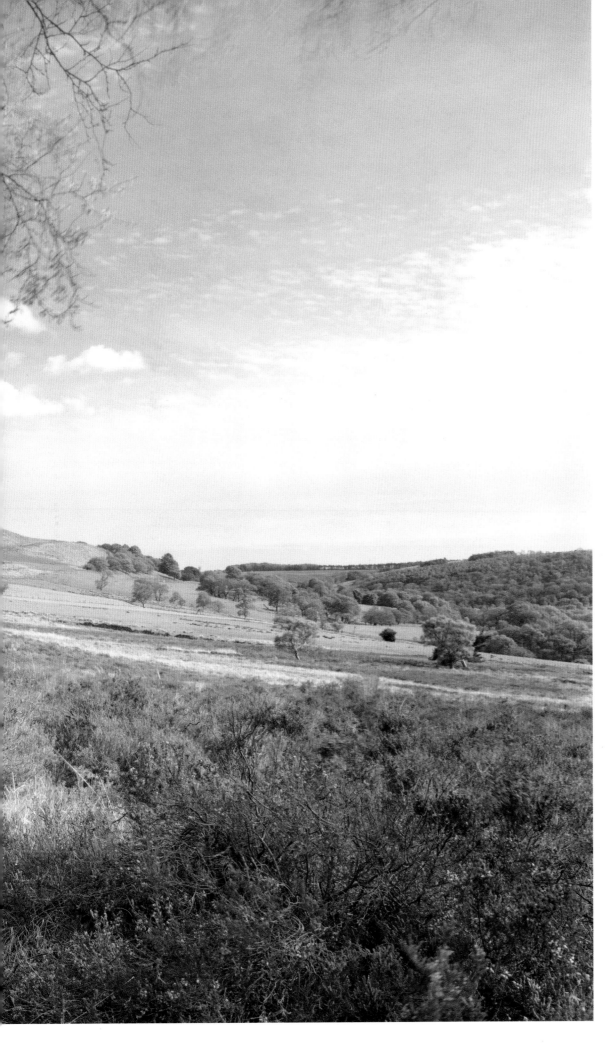

Hawnby Hill
North York Moors
England

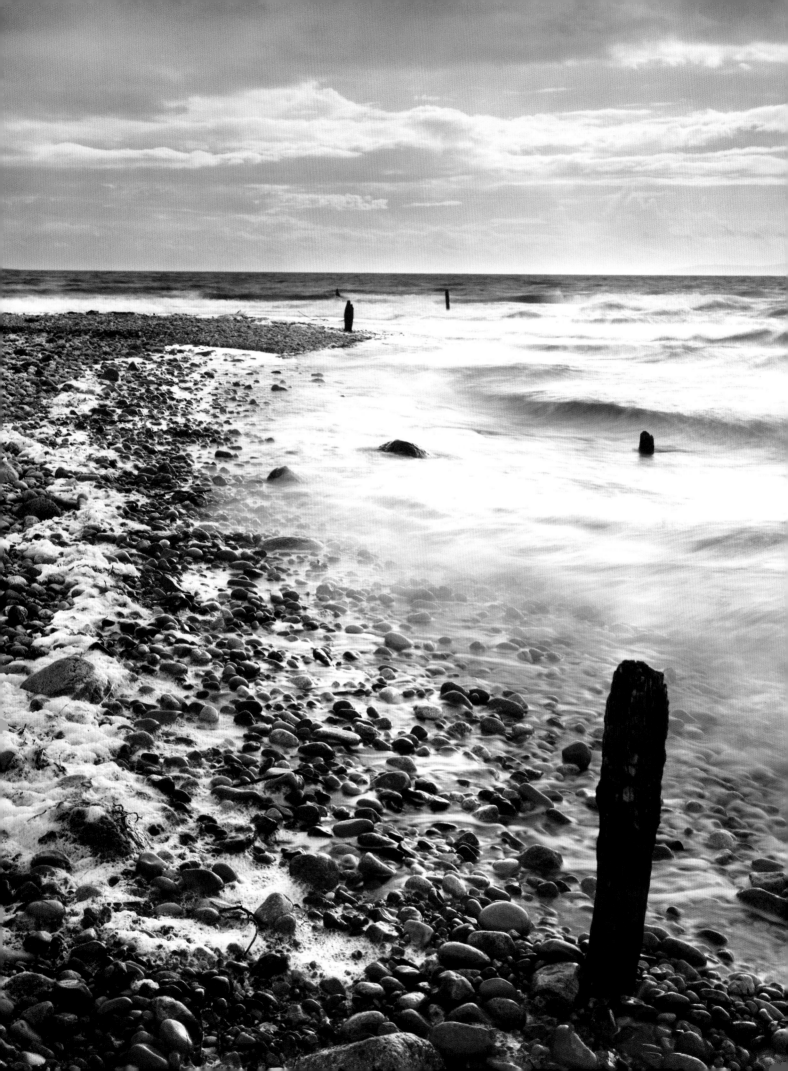

Even a basic understanding of the weather helps us be at the right place at the right time, to get conditions to suit the subject. It's often best just before or after a storm.

Vision

Learning to visualise how a colour scene will translate into mono is crucial if we are to achieve successful results on a regular basis. When working in colour, we have a fairly clear idea of how the result will look, but with monochrome this is almost impossible – so we have to rely on our experience and intuition. Some digital cameras offer monochrome modes, but the results are derived from the sensor gathering colour information. By visualising the scene in a series of tones without colour we gain a better understanding of what controls may later be applied in the darkroom or on the computer. This is why people are usually disappointed if they make an image in colour while making a mental note that it may 'possibly' become monochrome without considering why or how it could work in the latter medium.

Posts
Arran, Scotland

'When subject matter is forced to fit into preconceived patterns, there can be no freshness of vision. Following rules of composition can only lead to a tedious repetition of pictorial clichés.' Edward Weston

Tonality
I admire the discipline of colour photography, but find monochrome an even more exciting challenge. Careful visualisation, and proper consideration of tonal relationships will pay dividends. I was recently studying the Edward Weston's 'pepper and shell' series – one of the most celebrated bodies of monochrome work; I first saw these works when I was sixteen, and even now I am still in awe of the range of tones they display. Their impact does not arise only from the combination of camera, film and composition, but from the relationship of tones within each of the images. These prints glow and they leave an indelible impact on almost every person who sees them – and yet all they are is simple studies of peppers and shells.

Sandsend beach
Yorkshire, England

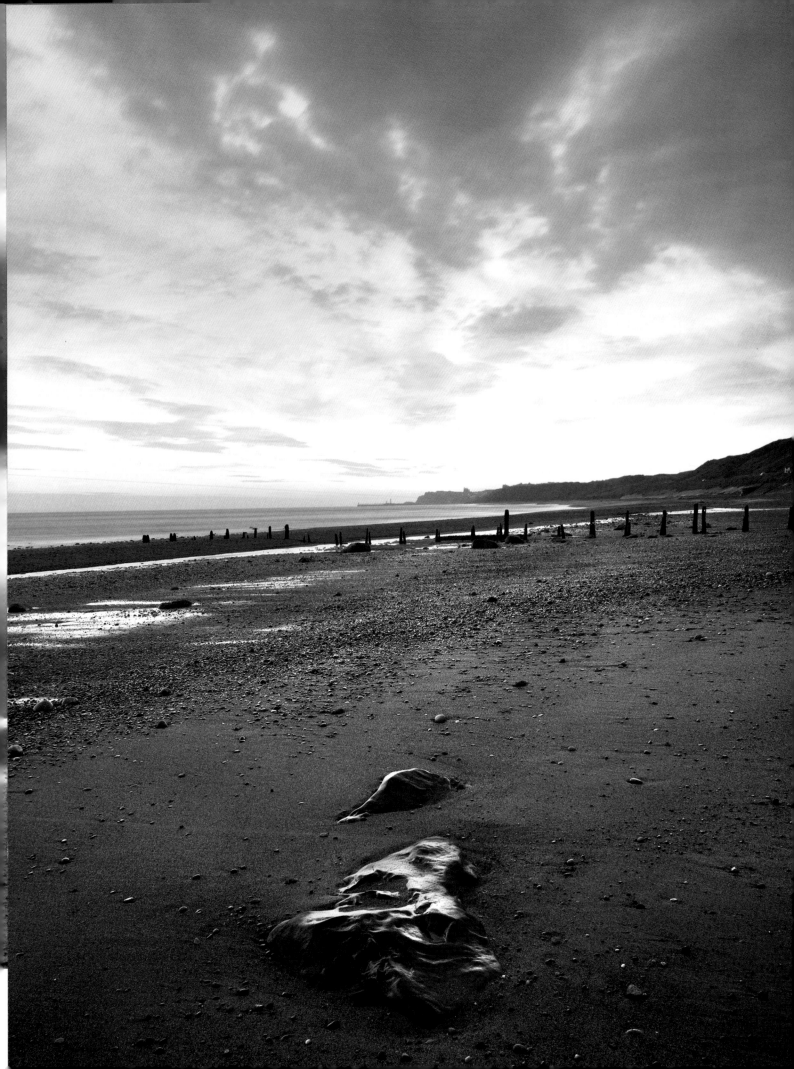

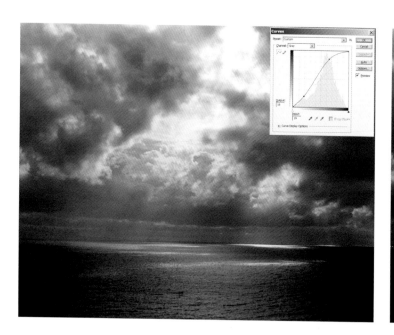

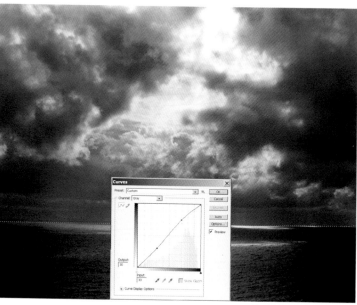

Creating an overall sense of mood
The first action was to apply quite a radical curve to the whole image to darken the shadow values, but peg back the sunlit highlights, to keep them bright.

Darkening the sky
A Lasso selection Adjustment layer enabled me to darken the sky slightly further, whilst retaining the mid- to highlight section of the curve line in its original position in order to retain contrast.

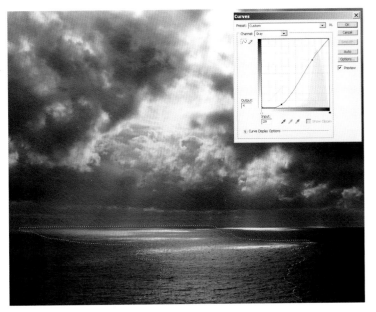

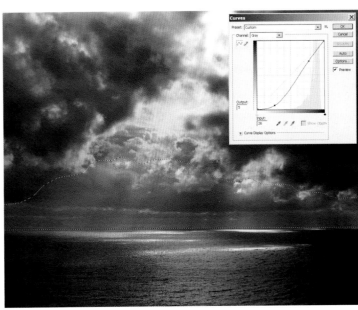

A sense of distance
In the image the sense of distance is conveyed mainly by the light on the open sea. A Lasso selection of the sunlit areas of the sea was made and the highlights were pulled considerably.

Controlling the upper sky
Lastly a Lasso selection Adjustment layer was made of the upper section of sky and this was darkened along with the very bright sunlit clouds to maintain tonal balance.

Simplicity: *It is all too easy to be drawn into the experience of being in the landscape, but for a picture to succeed, it may only need to contain a fraction of what we see. Reduce the chaos and only include those elements that contribute expressively to the composition.*

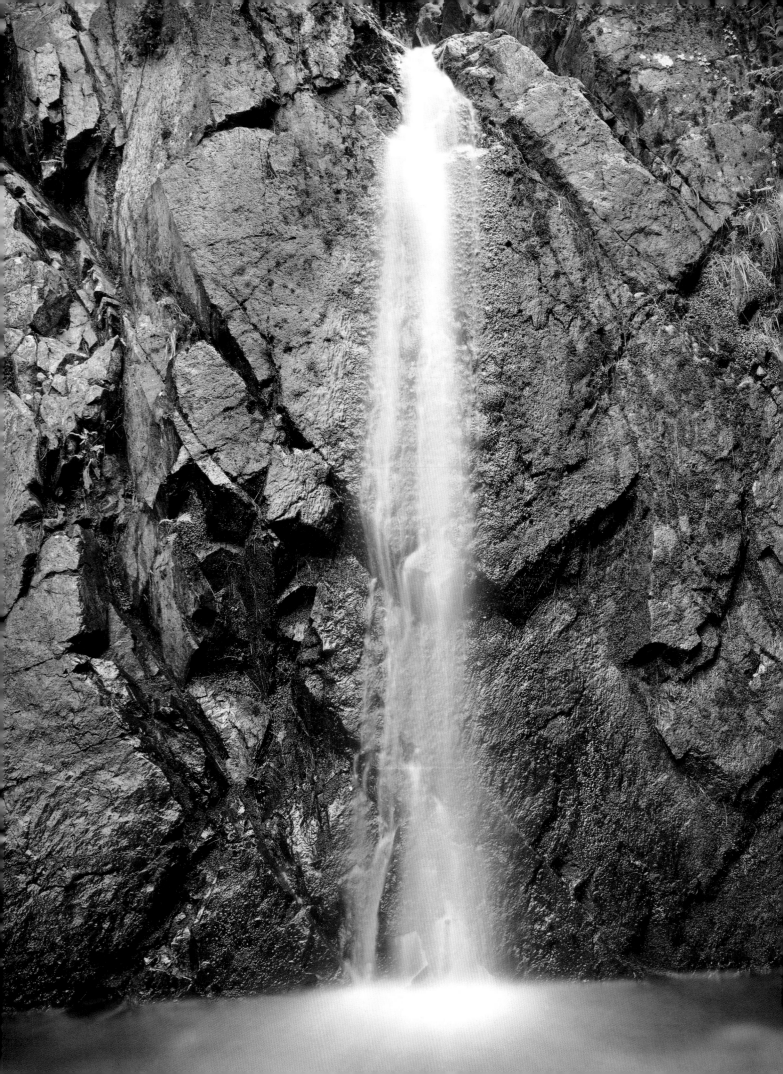

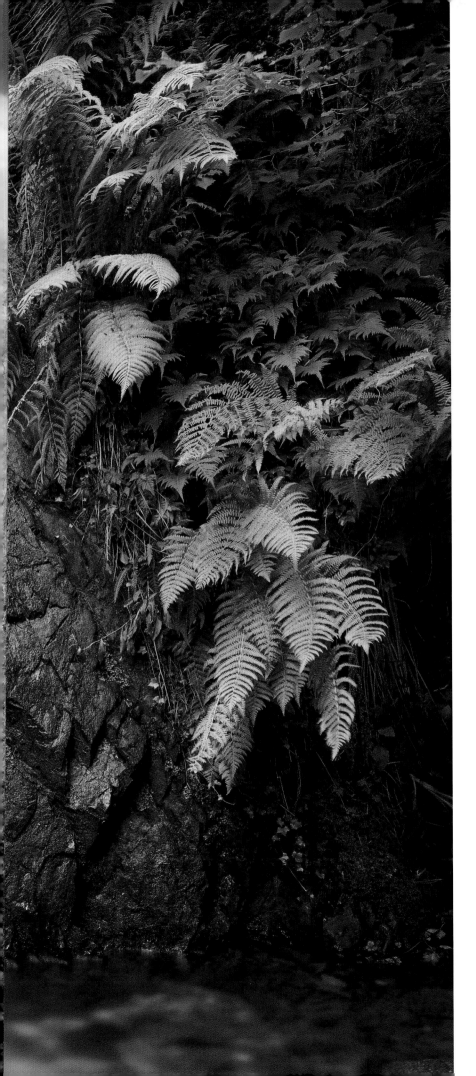

Only the combination of visualisation and the application of technique can bring about the realisation of an expressive image.

Waterfall #1
Honister, Lake District
England

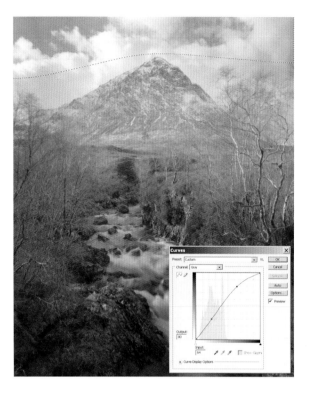

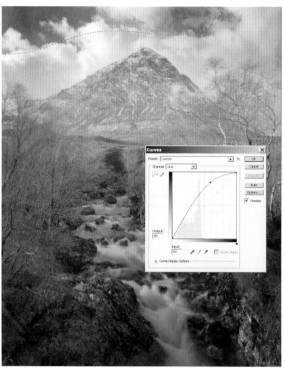

Balancing the greys within the picture
I began by making a Lasso selection
Adjustment layer of the sky and darkening
the upper section to balance this with the
other greys in the image.

Accentuating the upper sky
Making a more restricted lasso selection in
the sky I further darkened the section of blue
sky that appeared behind the clouds. This
darkening gives the sky a greater presence
in the composition and also shows the
movement of the clouds which is essential to
the success of the image.

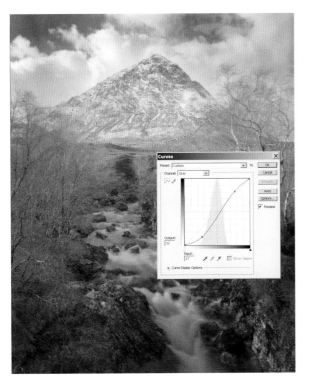

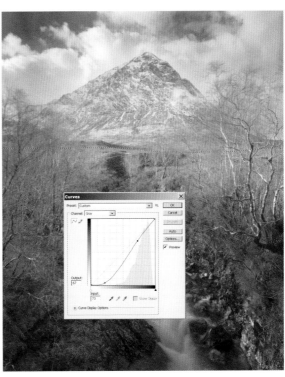

The contrast on the mountain
The body of the mountain was then selected and contrast was increased which helped differentiate between the dark, wet rock and the dusting of snow. Now the mountain began to look somewhat ominous.

Giving life to the foreground
The final curve addressed the lack of contrast and 'light' in the lower section of the image and trees. The curve shows that I pulled in a lot of highlight values that help to emphasise the impact of the evening sun on the trees.

Viewpoint: *the challenge with landscape photography is always to convey the scene in a personal way. Well-known, familiar locations, in particular, require a fresh viewpoint.*

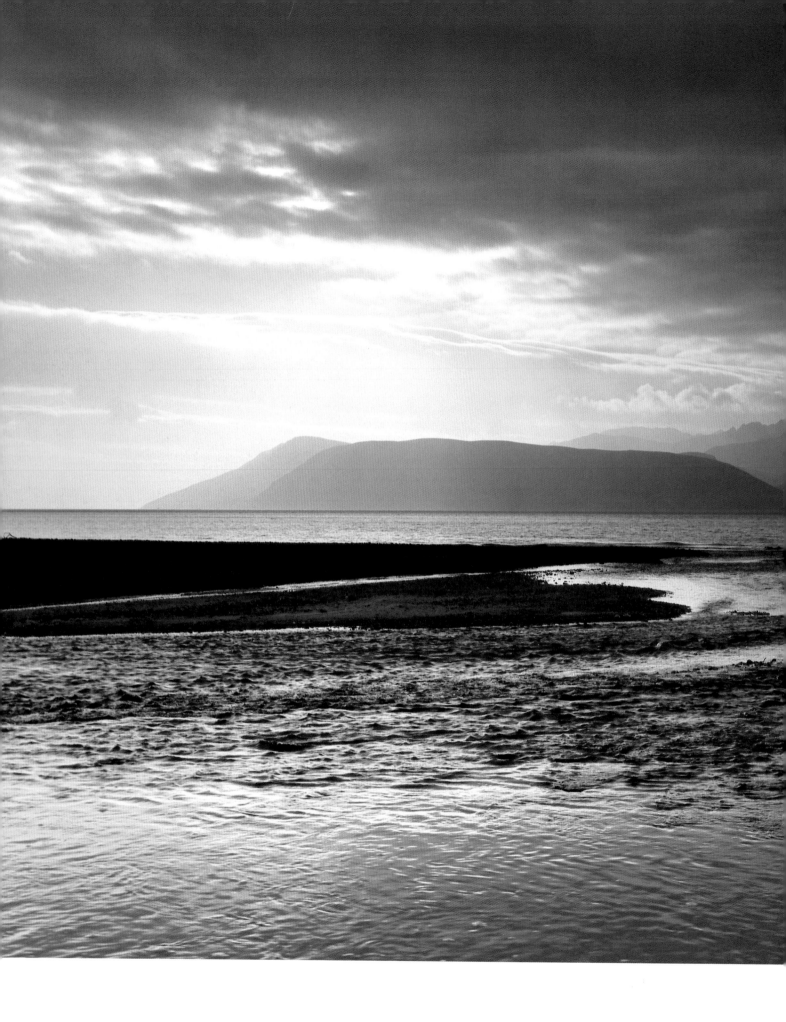

Imagination

In many ways, the lack of colour
information in a monochrome
image enhances it rather than
detracting from it, and our brain
is still capable of comprehending
and interpreting an image without
colour. Imagine a red ball on lush,
green grass in fine, direct sunlight.
If this set-up were photographed
in colour, we would first notice
the vibrancy of the red and the
green, before breaking down any
further information about the
picture. Viewed in monochrome,
the same image would instead
become a study of form, line,
texture and shape. We would,
of course, know it to be a ball
on grass, and that the grass is
green, and we would be able
to interpret the direction of the
light source and its intensity. We
would be left only to deliberate
over the colour of the ball.

Sunrise
Arran, Scotland

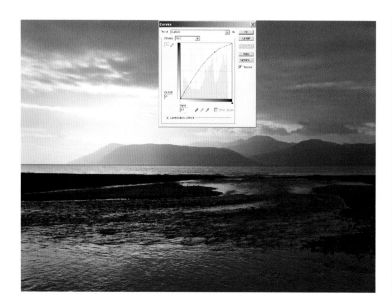

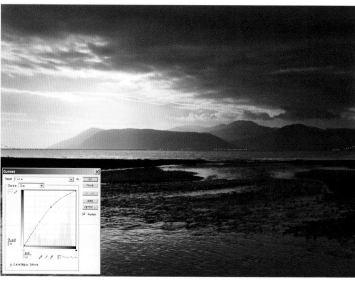

Darkening the whole image
The initial global curve served to darken the whole image, also allowing the highlight values to be muted in the curve adjustment.

Darkening the passing storm clouds
Selecting the upper part of the image, the sky was darkened further to add weight to the passing storm clouds and balance them against the darker foreground beach and water channels.

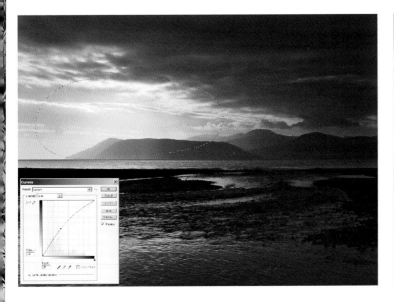

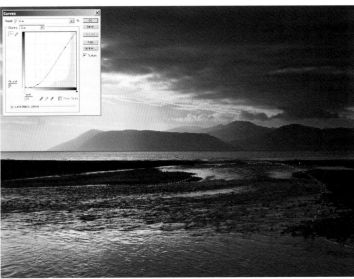

Controlling the highlights
An oval Lasso selection was made of the brightest sunlit area of the sky above the Isle of Arran with a very large feather so the adjustment would not be seen in the finished image. The highlights were toned down further to bring out the subtle details in the lighter clouds.

The finishing touches
The final curve was applied to the selection of the running water at the foot of the image. The highlights of the curve were pulled to accentuate the reflective quality of the water against the rising sun.

Alternatives: *the light that is present may not always be the best. Re-visiting a location under different conditions or at different times of the day or year may provide a better alternative.*

Long exposures can help to bring order from chaos, and soften what might otherwise be harsh. One of the powers of monochrome is that viewers can make their own interpretation of the image.

Waterfall #2
Honister, Lake Disctrict
England

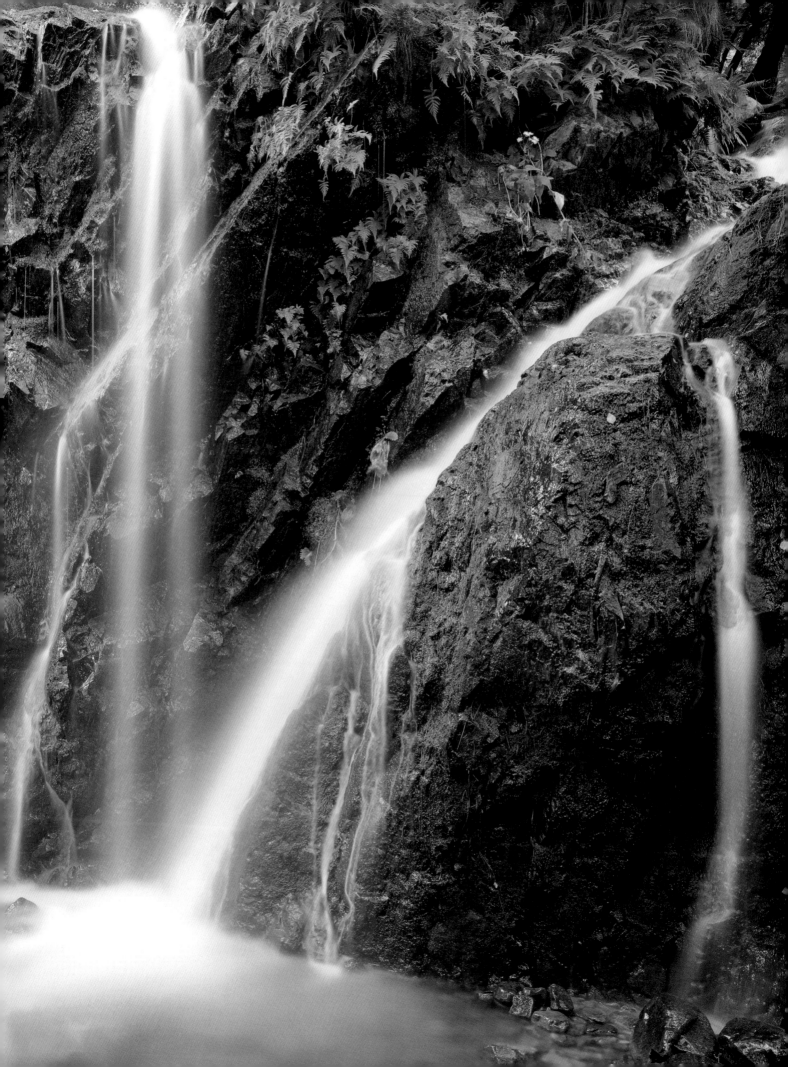

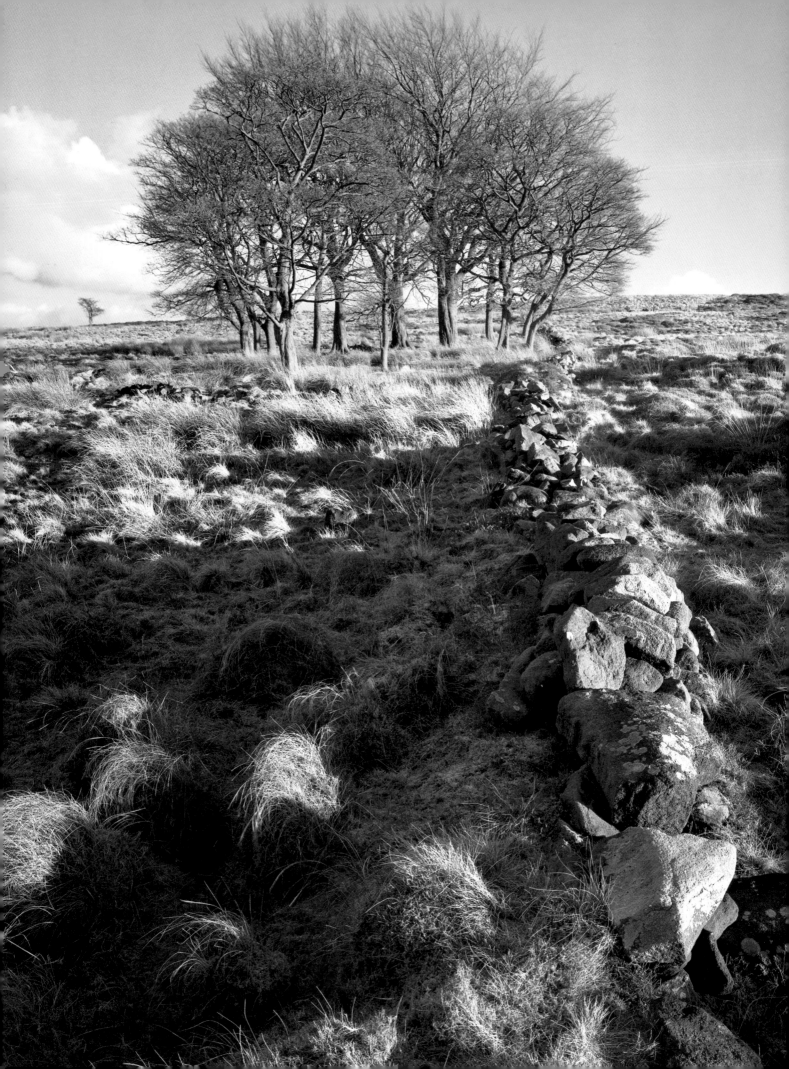

I should never assume that there is a fixed time at which to venture out with my camera, nor should I rely upon a fixed set of weather conditions that I regard as suitable for a successful photograph.

Expression

Developing the negative or processing the RAW files completes the first stage in the proceedings; now the world of printing, with all its creative possibilities, opens up. The moment in time can only be captured once, and the negative can only be processed once – but the printing or manipulation can involve many stages and evolve over time. One of the photographer's main responsibilities is to determine the point at which the image is complete. Only he or she can decide how it should look, what tools to employ and to what extent they will be used. The crucial point to bear in mind is not to overdo things, which can all-too easily result in an image that is devoid of any expressive value at all.

Copse
Lancashire, England

'Whether he is an artist or not, the photographer is a joyous sensualist, for the simple reason that the eye traffics in feelings, not in thoughts.'
Walker Evans

Visualisation In monochrome photography

I feel I have a distinct expressive advantage. When working with colour negative or transparency, the photographer is obliged to execute much of the pre-visualisation in camera. In monochrome, however, I may see the final image in one way at the moment of capture, but in another when it comes to printing it. I have sometimes produced a rough scan from a negative, or a test print in the darkroom, and hung it up for as long as a month before making the final decision about how to tackle the final print.

More often than not, however, and purely because of the way in which I work, I aim to reproduce what I visualised at the moment of exposure. As a result, I tend to plunge into the printing stage immediately, in the hope of revisiting the emotional experience I encountered in the field. I worry that if I delay too long I may lose the immediacy of the photographic moment; looking at a straight scan or print for a prolonged period of time might result in me forgetting why I exposed the film in the first place! If you feel a strong connection with a place when you visit it for the first time there is always a danger that, if not immediately recorded, the memory will fade and become overlaid with memories of subsequent visits. If an exposure was made, it was for a specific reason, and the print should express this.

Black Cuillin
Skye, Scotland

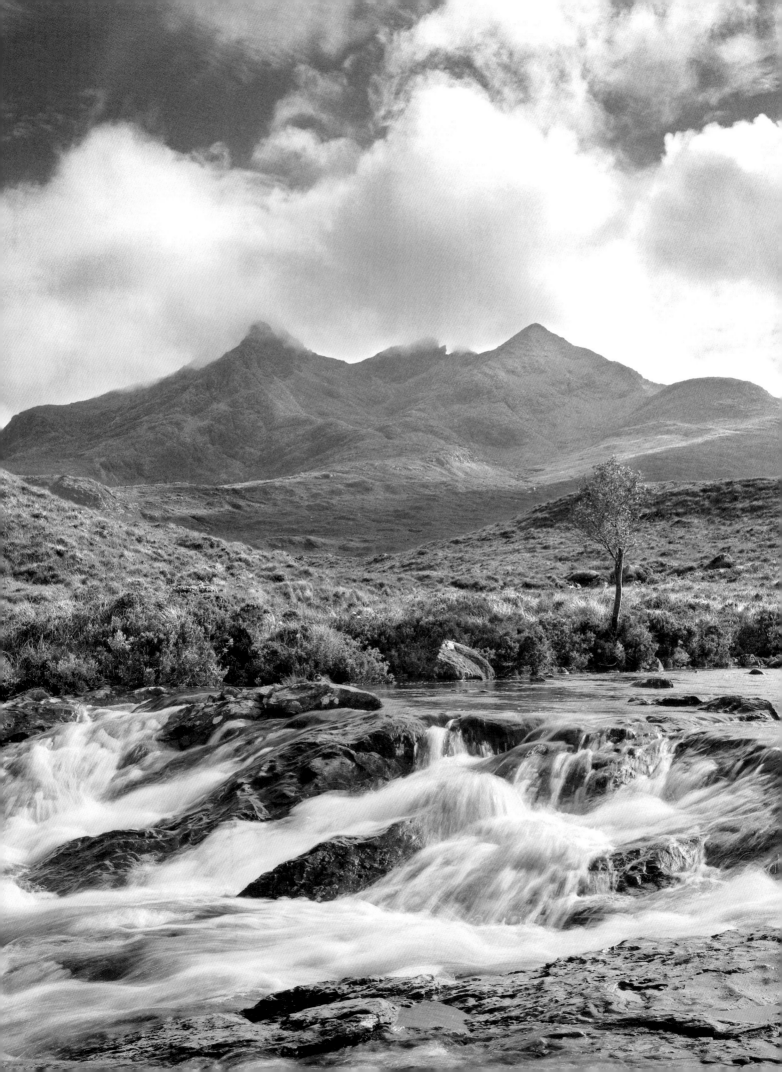

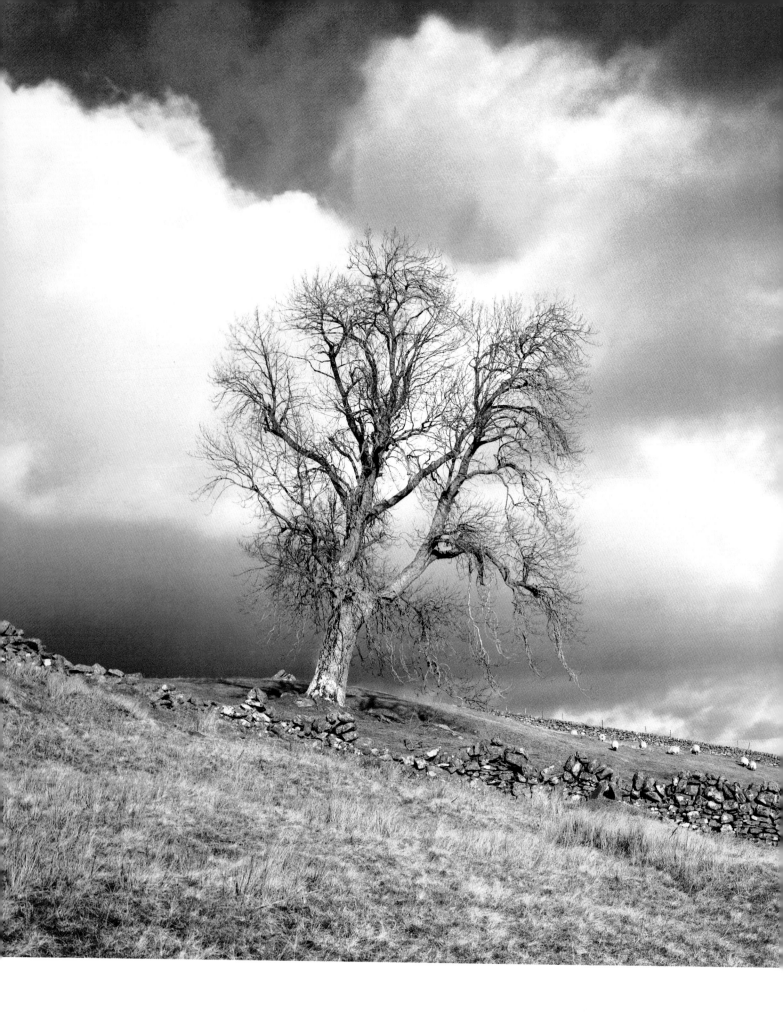

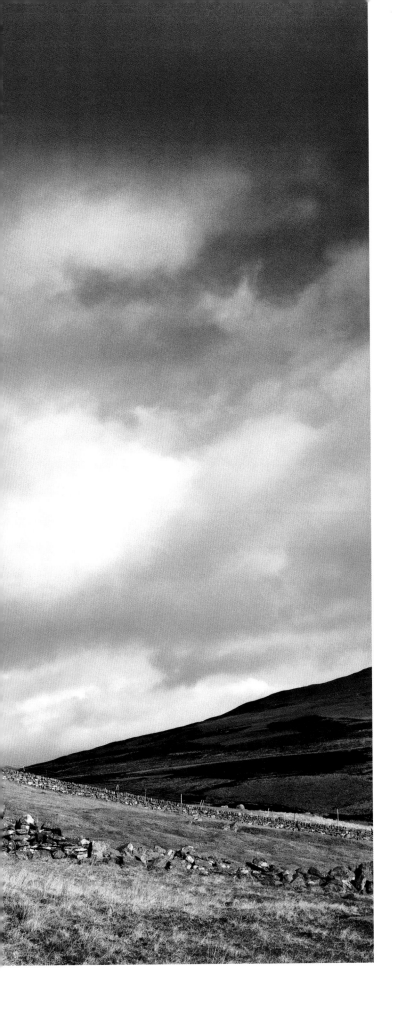

Nothing beats practice for reaching a point where we really understand the relationship between tones

Storm and tree
Perthshire, Scotland

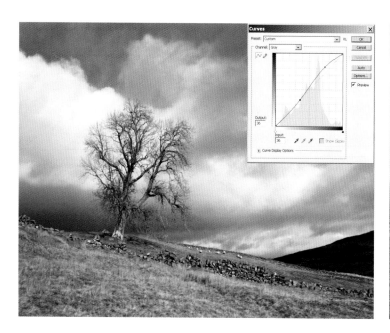

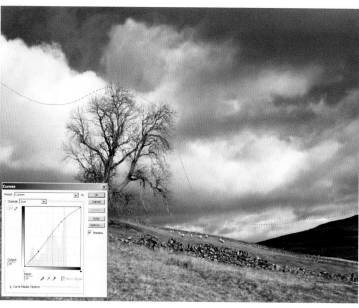

Strength of light

My starting point was to darken the overall image while maintaining the highlights. This began to introduce the strength of light to the print.

Darkening the sky

After selecting the sky using the Lasso tool with a very large feather, I then darkened the storm clouds further, pegging the highlights back in the curve line.

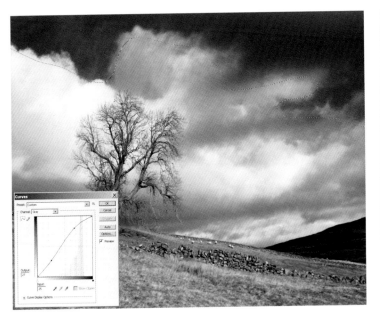

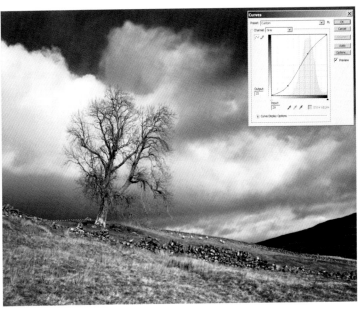

Adding drama
I felt the upper part of the sky, which is an essential part of the composition, needed to be darkened further, adding the drama I had originally visualised.

Working on the foreground
I created another Lasso selection of the grass and with a Curves adjustment layer accentuated the feeling of late evening light.

Symbiosis: when portraying the relationship between a subject and its environment, it is essential to have weather and lighting conditions that convey the symbiosis of the two.

'Photography, as we all know, is not real at all. It is an illusion of reality with which we create our own private world.' Arnold Newman

Interpretation

For me, there are no golden rules at the printing stage, not in the way there are with the image-capture or film-processing stages. Make a mistake with your camera exposure, or process a film wrongly, and you've probably lost the picture forever but when it comes to manipulating an image file or negative, the possibilities are endless. Some photographers find comfort in rules; for example, that a good monochrome image should feature the full tonal range with few, if any, total blacks or whites, even though other photographers – such as Michael Kenna – make astonishingly expressive prints by disobeying them. Such rigidity is the hallmark of 'mechanical' photographers, for whom the technical process takes priority. For me, such technical comfort-blankets ultimately suffocate expression and yield good, but not outstanding, images.

Kirkcudbright Bay
Dumfries and Galloway,
Scotland

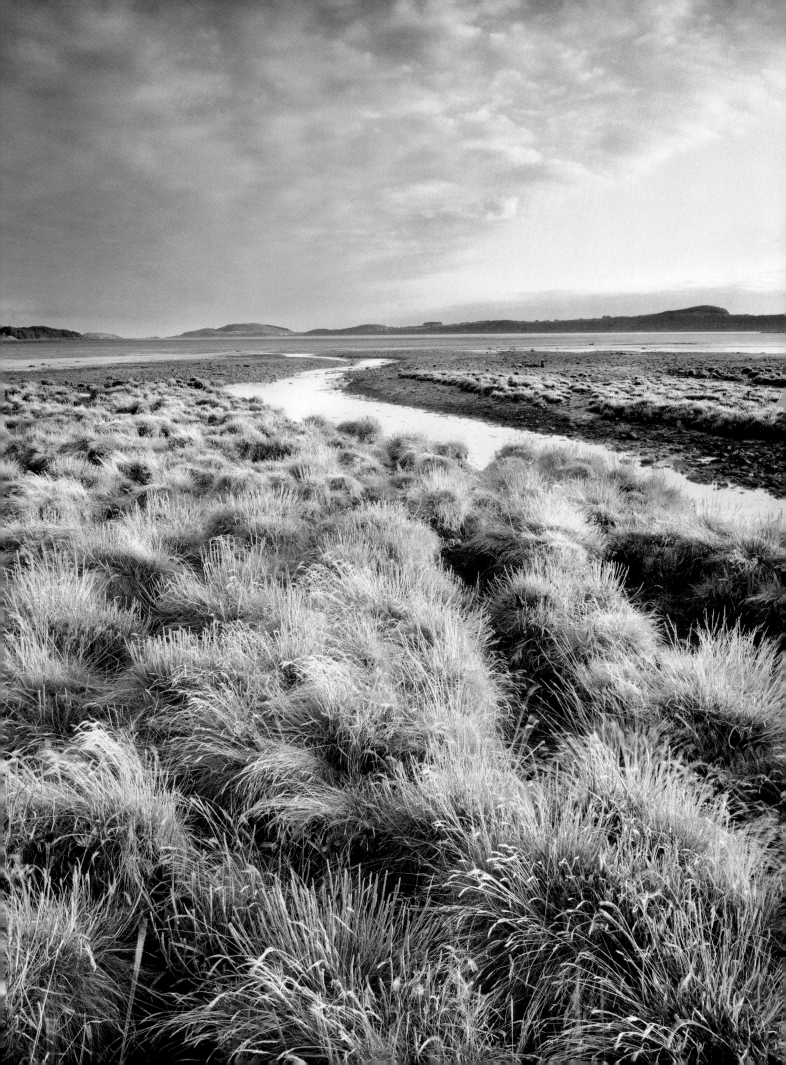

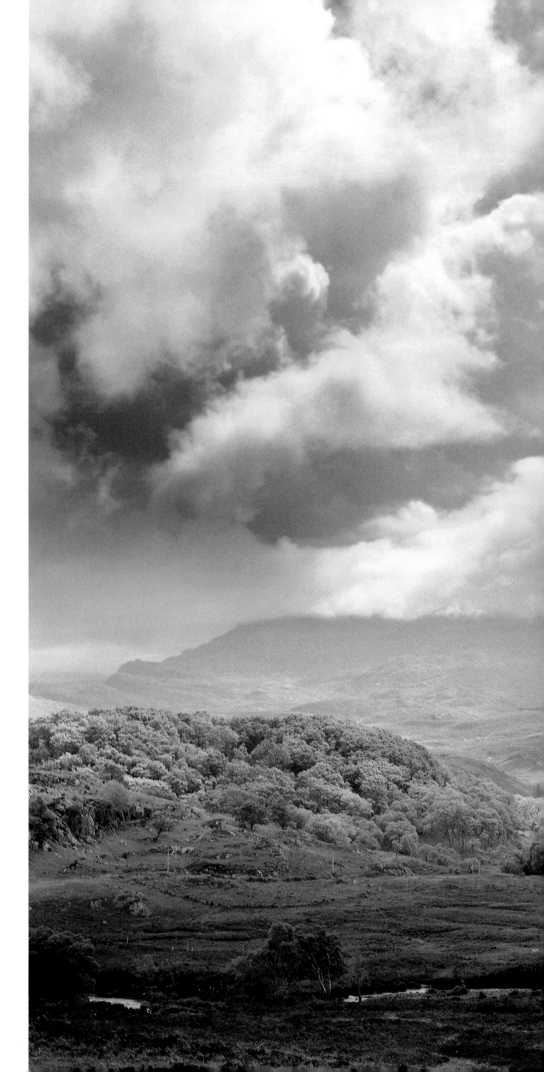

Loch Maree
Wester Ross, Scotland

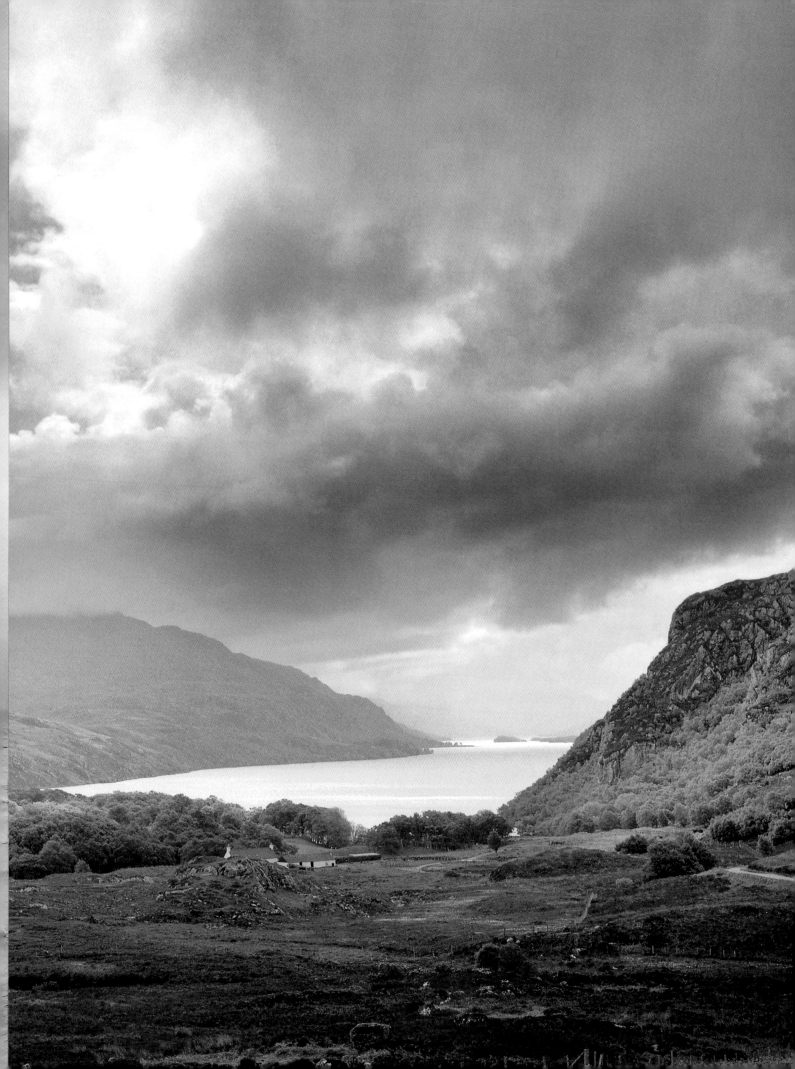

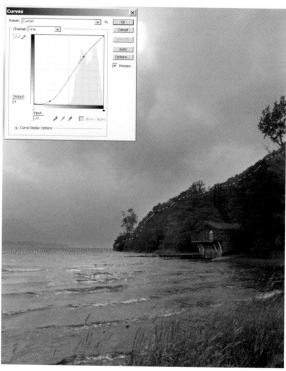

Bringing out the detail in the clouds
The first Lasso selection and Curves adjustment layer began the process of teasing out detail in the clouds.

Avoiding a halo effect
The second Curves adjustment layer was very similar to the first, but the Lasso selection encompassed the tree tops, to prevent a halo above them when I darkened the sky yet further.

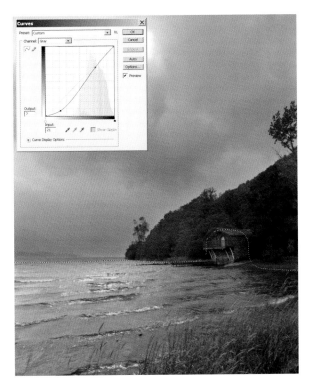

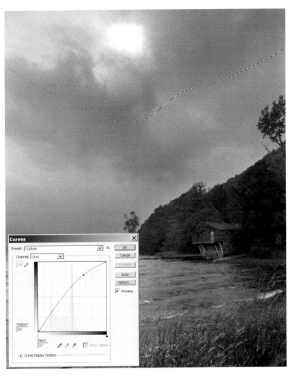

The boathouse and the lake
Making a Lasso selection of the boat house
and lake, I pulled the lighter values in the
curve to accentuate the feeling of light.

Bringing out the sun
I selected the upper area of the sky once
more and used another Curves adjustment
layer to darken the clouds, making the sun
stand out.

*Weather: so often the weather conditions
make the composition. Wind, rain, fleeting
sunlight, mist, cloud, snow – to name but a
few – all affect our view of a landscape.*

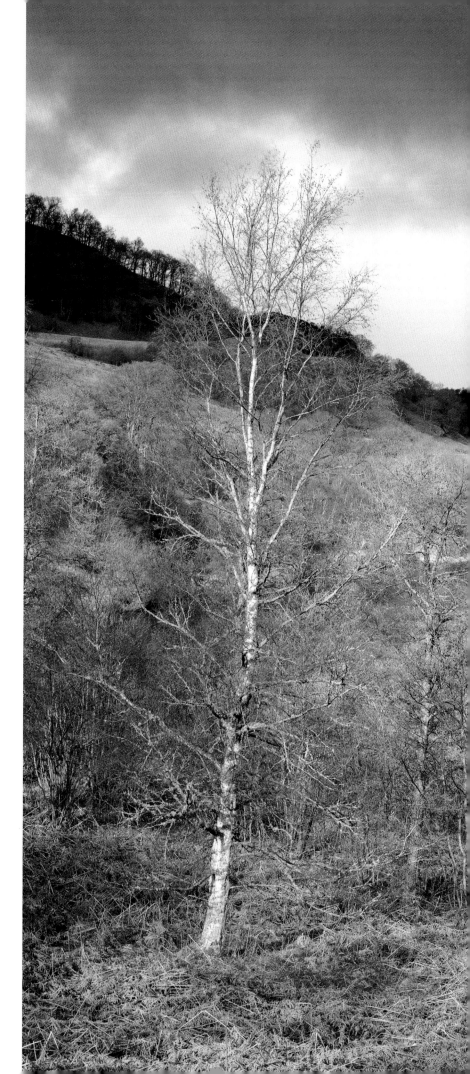

Some landscape photographers go as far as using a dark red filter for every picture – and then scratch their heads because of the poor tonal range in trees and lush vegetation in their images, not realising that a red filter absorbs green light.

Killiecrankie
Perth and Kinross,
Scotland

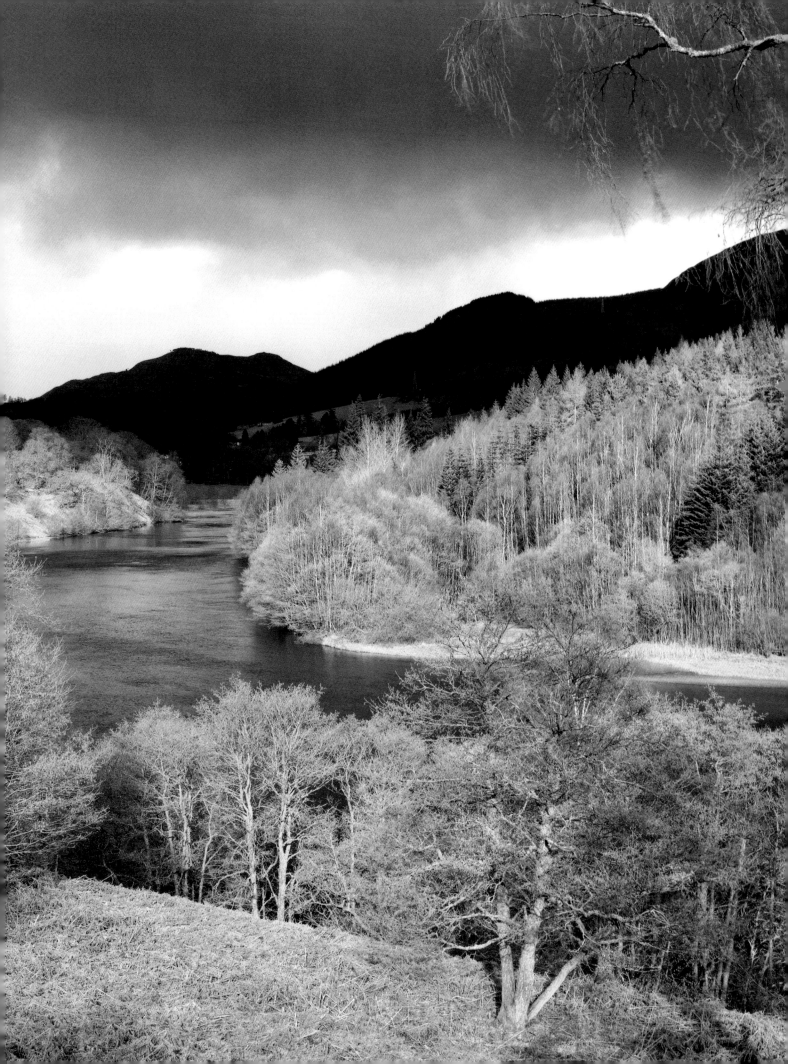

'Photography deals exquisitely with appearances, but nothing is what it appears to be.' Duane Michals

Completion As we mature, the way in

which we appreciate and respond to a subject also changes.
When I look at images I made years ago I know that were I to
reprint them today they would continue to be expressive, but
in an entirely different way. As time passes, our interpretation
of a particular moment – not to mention our response to that
memory – alters, and this will be expressed at the printing stage.

By all means study the advice offered in magazines, but tread lightly
when it comes to printing techniques and allow time for these to
emerge from within rather than letting them be imposed by others.
The expressive print may be subtle in tone or heavily printed. The
relationship of the tones in the image and their interaction within
the composition can act as an extremely powerful tool. As John
Szarkowski said of the work of Ansel Adams, 'He translates the
anarchy of the natural world into perfectly tuned chords of grey.'

Slioch
Wester Ross, Scotland

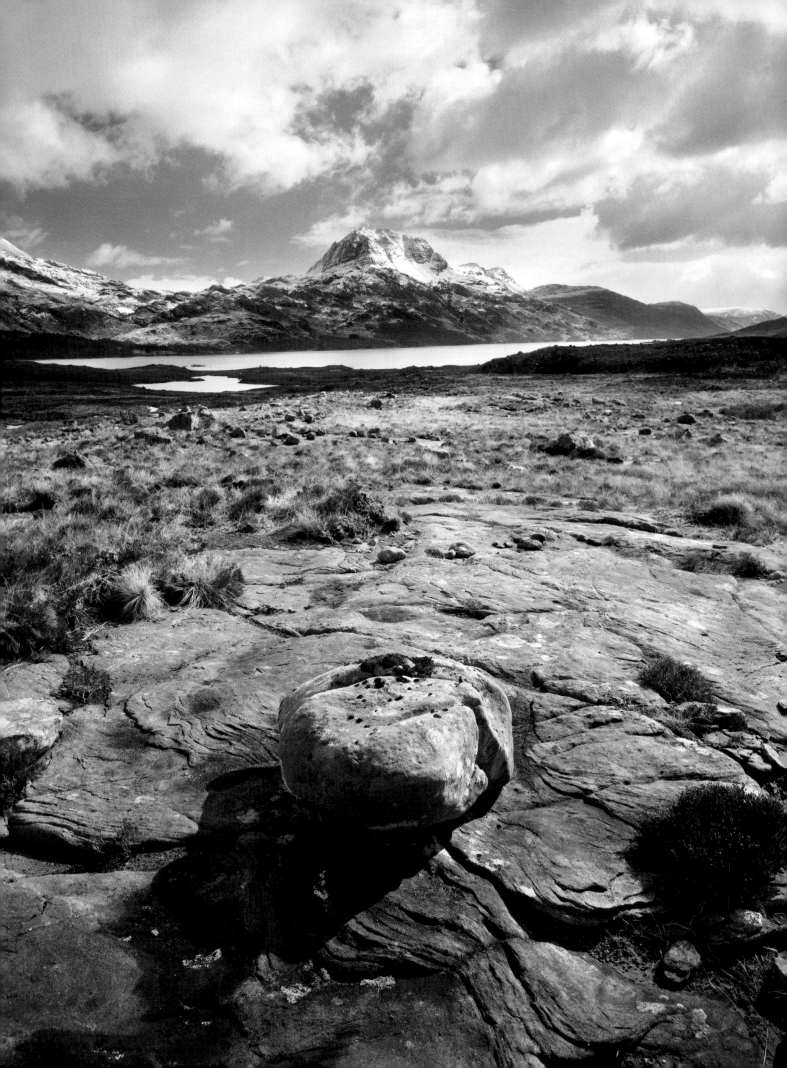

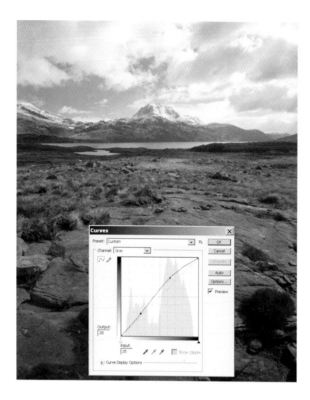

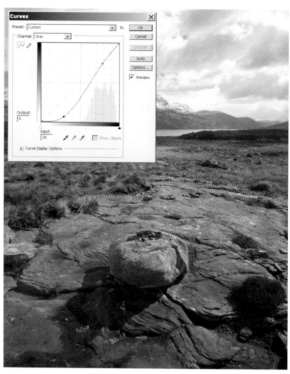

Adding depth
An initial global Curve was applied to add depth to the darker values in the image and very slightly mute the highlights overall. I was careful to retain the essential shadow detail of the foreground boulder.

Brightening the foreground rocks
Breaking the image up into sections, I then selected the foreground rock outcrop and brightened its lighter values, to enhance the sunlit effect.

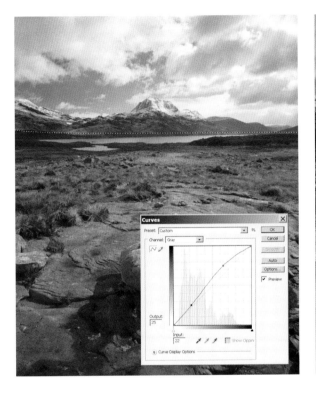

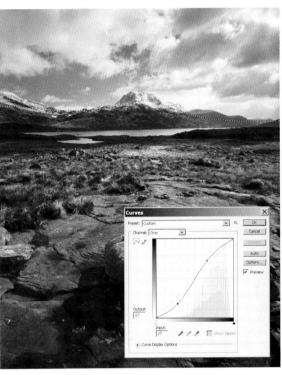

Bringing out the detail in the sky
A simple Curves adjustment layer was used to bring out the detail in the the upper part of the composition, including the mountain and the sky. The highlight section of the curve was pegged down to maintain the brightest values.

Giving life to the foreground
Finally, the entire image minus the sky was selected and overall contrast was increased with a Curves adjustment layer.

Format: *when working in portrait format, the foreground composition is important, especially if a wide-angle lens is used. Consider what the foreground consists of, and what that says as it leads the eye into the picture.*

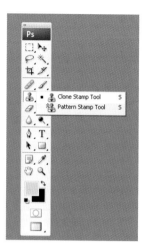

Top row:
Clone tool
This is especially good for dealing with dust marks and blemishes.

Healing Brush tool
I find this useful for dealing with more general, larger areas, such as skies, as it gives a very smooth, blended result.

Dodge and Burn tools
As in the traditional darkroom, these are good for making specific areas lighter or darker.

Lasso tool
I use this to select areas that I want to adjust, usually with a Curves adjustment layer. The edge of the Lasso selection can be feathered, with the Feather option.

Bottom row:
A Curves adjustment layer
This shows the curve on the left and the layer it sits in on the right. As the curve is adjusted, so the image can be seen to change. If a Lasso selection Curves adjustment layer has been made, the selected area will change as the curve is adjusted.

Making a new layer
Here a new Curves adjustment layer is being created.

It is wonderful to use a hand-made camera and the best lenses, but a photographer who becomes reliant on these alone will never make good deficiencies in vision and a lack of understanding of light.

Methods

Camera & Kitbag I am often asked why I still go to all the trouble of shooting film and then dealing with the associated hassles such as processing and reloading dark slides. I do not consider myself to be particularly sentimental about these things and I stick to film because it still provides me with the control and results that I need. The reason I continue to use a large-format camera is that it offers a vast range of movements which allow me to 'manage' the image out in the field prior to exposing the film. The use of tilt for extended depth of field and of adjustments on front and rear standards to control converging verticals have become automatic for me and are facilities that I use to refine every image. I am also very accustomed to visualising a scene and then making the final adjustments cut off from the real world in the pseudo-darkroom beneath the focusing cloth. It may sound crazy, but I am almost oblivious to the fact the image is inverted and back to front; indeed I feel that this helps by providing a wonderful understanding of balance and structure.

Photoshop tools
Opposite are the printing tools
I use most frequently, that give
me the control I need.

The camera that I currently use the most is the Ebony 45SU but I have also made many excellent images on my Walker Titan XL. The lenses I carry in my bag at all time are a 72mm XL Schneider Super Angulon, a 90mm Rodenstock Grandagon 'N', a 150mm Schneider standard lens and a Schneider 210mm. I do use longer lenses, but only occasionally and therefore tend to avoid carrying the extra weight as much as possible. I would be lost without my Schneider 4x loupe and selection of good, heavyweight cable releases and, because I still load dark slides and very seldom use Quickload, my bag is pretty heavy and takes some lugging around when a long walk is needed to get to the end of a remote Scottish glen!

When it comes to filtration I use the Lee series of black and white resin filters. The filters I most often use are yellow, light red and, more occasionally, green and dark red. I never walk around with one filter type attached to the lens and always consider carefully what I am trying to achieve by filtration.

For metering I only ever use a hand-held spot meter. I suspect that this is one of the most important things in my bag as it enables me to gauge the light I am trying to capture and decide in what way I will interpret the brightness range of that light. If I was not able to do this and ascertain where to place my zones of grey then the entire exercise could become rather hit and miss, although with practice I have become adept at exposure estimation.

On occasion, I do make images using a digital SLR. For this I use a Nikon D70s and always shoot on RAW using the manual setting and a spot meter. The fantastic option of making an exposure and being able to view it is still something of a fascination for me even though I have had the camera for several years. All your processing and initial image viewing done in a split second! I am sure that one day I will move to digital and wallow in the benefits of a fully digital workflow.

Along with many cameras, I seem to have accumulated many tripods over the years, but my favourite combination is my Gitzo GT3540 carbon fibre with the wonderful Manfrotto 405 geared head with which I can dial in my horizons and verticals to match the spirit levels on my camera with the accuracy of a craftsman.

Film I have tried many differing films over the years and now have settled for Ilford Delta 100 because of its superb grain structure and tonality. I am often asked why I do not expose colour emulsions which will give me the option of a colour or

monochrome image at the end. The answer is that I still relish the control offered by monochrome at the developing stage. I can curtail or extend development, increase or reduce temperature or agitation and, of course, change my developers to provide the exact contrast control I need.

The developer I use the most is one devised by Peter Hogan. He has designed and refined many fine developers over the years and in my experience, for scanning purposes, his Prescysol EF is invaluable for its superb fine-grain structure and high acutance and because it is a tanning developer. (The developer can be found at www.monochromephotography.com). It goes without saying that, regardless of what film-developer combination you use, accurate metering and exposure will always be the essential starting point.

Computers I am in no way shape or form a computer wizard – actually more of a computer klutz! I am a landscape photographer and I am only interested in equipment if it enables me to further improve my images. I have largely left the darkroom behind and opted for digital print output purely because I deemed this workflow to provide me with more control over the appearance of the final image.

When I started out using computers my machine was grossly deficient, it was virtually impossible to profile my monitor accurately and my scanner was spectacularly awful at scanning negatives! The results reflected these shortcomings and at that time I chose not to decommission my darkroom! Now I have two systems which I have come to love, as opposed to loath, although they do frequently shock me with immensely confusing error messages which I promptly pass on to my good friend and colour-management expert Mike McNamee.

My main computer is a PC. I have a system that consists of a Pentium 3 GHz dual core processor with 2 GB of RAM and 250 GB of hard drive space. Along with this I use an Ilyama Pro E485S monitor. I also have a 400 GB external hard drive which I have set in sync, which means that at the end of every working day it will only replace and update files that have been altered or introduced to the system. This is important for anyone relying on digital technology and the pitfalls of file storage.

My second system is Apple Mac. I have a G5 Quad Mac with 6 GB of RAM and 500 GB of hard drive space. The monitor I use is the 30-inch Apple Cinema HD Display which I find outstanding for viewing images as it can be positioned to almost fill your field of view.

My digital regime I recall my first image adjustments in Photoshop, they were crass and overdone, and I had no real concept of what I was doing. Before that, when I was starting to print in darkrooms, I first learned the basic rules of engagement and then gradually gained an understanding of what those rules meant to me in terms of making images. I called it 'hands on progression' and I have followed that approach with Photoshop.

We must first learn which facets of the program are useful to us (remember, Photoshop is also a tool for designers, graphic artists, editors and publishers, to name but a few) and then learn how to apply these to making our images. The range of tools I use the most are shown on page 110.

Once the application of our chosen tools has become second nature to us we can focus our minds on the most important task in hand which is the printing of our visualised image. Believe me when I tell you that trying to learn and apply the techniques used in image-manipulation software while at the same time attempting to realise your vision will almost certainly lead you to become either disheartened or frustrated!

Scanning I use a high-end, Epson V750 flat-bed scanner for my 5x4 large format sheet film and my back archive of 6x7cm negatives (but I'm still to be convinced that that one would be good enough to scan 35mm negatives). I've compared my Epson V750 Pro against a virtual drum scanner and the results hardly differed at all. So, I feel that when choosing a scanner it is not quite a simple case of 'you get what you pay for' at all.

When scanning, first I select Film as the document type, set the Film Type to B&W negative film and then make sure I have selected 16-bit greyscale (I always scan at the best bit-depth possible). There is some confusion as to whether it is better to scan a monochrome negative in greyscale or RGB. Having tried both methods I see little benefit in scanning in RGB and I am often distracted by the colour cast it produces. At this stage there is also the option of selecting a level of unsharp masking. I often set this to the lowest setting which I find offers a little edge to the image when it arrives on my screen after scanning. It is worth mentioning that any form of digitising negatives or prints by scanning them will 'soften' the end-result and some form of sharpening is required.

Next we can press Preview and the scanner will make the first pass over the entire negative area and a preview of this will appear. At this stage you can see the negative for the first time in positive form and if you know that you intend to crop the negative, do it now as cropping in Photoshop will reduce your workable file size.

With your negative area selected for scanning you can then begin initial adjustments prior to committing to the final scan. For this you have the choice of Levels and Curves along with Brightness, Contrast and Colour Balance if you are scanning colour materials. In Curves there are a number of preset curves to choose from but I recommend making your own adjustments and taking control. My recommendation is that you try to obtain a full tonal range for when the image is opened in Photoshop, after which you can refine the tones. When you have made the adjustments to image area and tonal range you can commit to your scan with the peace of mind that comes from knowing that if it is not quite right you can simply go back to the <File > <Import> command and start from where you left off, as all the initial adjustments and scanner settings will be retained until you switch off the scanner or scan another negative.

What I recommend is that when you first open the image you press Ctrl+L to open the Levels dialogue box. When you have this box open if you hold down the Alt key and at the same time click on the Black end slider in the Levels dialogue box your image will suddenly go white. If you see black areas appearing through the white, these are areas in your image that will contain no shadow detail and will print as solid black. Similarly, if you do the same with the White end slider your image will turn black and any white areas are highlight areas that contain no detail and will print paper white. If I find that either of these is the case I go back and rescan my negative.

Cloning and healing Quite often an image displays some form of artefact, maybe a speck of dust or a hair that found its way on to our scanner glass, negative or digital sensor. There are many ways to remove these little annoyances but I have found the simplest (and if I am to be honest, the most therapeutic!) is to use either the Clone tool or the Healing Brush tool. Both work in a similar way. You place your cursor next to the offending artefact, press Alt and click, and as you do you will see a small 'target' cursor appear. When you do this you are effectively sampling the pixels beneath your cursor. If you then place your cursor over the offending area of the image and simply click, the speck should disappear. Generally, before doing this I tick Sample and Aligned at the top of the Photoshop window.

The Clone tool and the Healing Brush tool in fact work in very different ways, although they may appear similar on screen. The Clone tool simply copies and pastes what you sample, whereas the Healing Brush tool samples the area and, through a complex algorithm, averages out pixel tones and image structure, making the healing process almost seamless. This is especially useful in skies and other areas where there are no defined hard edges; but when edges are involved I always turn to the Clone tool.

Adjustment Layers
The first point to make is that the use of adjustment layers will not degrade your original file as all the changes you make happen on separate layers 'above' your original. Secondly, the use of adjustment layers enables you to go back to an earlier point in your image manipulation and further adjust or tweak your initial settings. You also have the option of altering the opacity of an adjustment layer, which could be described as altering the 'volume' of what you have done with that particular layer and also there is a vast choice of blending modes.

Adjustment layers can be accessed in two ways: either by selecting Layer>New Adjustment Layer and then selecting the tool you want to employ, or alternatively by clicking on the small half black/white circle icon at the foot of your Layers palette which will cause the same set of adjustment options to appear.

Sharpening images
One of the commonest ways for an image to be ruined occurs in the final stages when sharpening is applied. The simplest rule to remember is that less is more, otherwise you are likely to introduce a fine veneer of grit or crunchiness to your images.

When you sharpen an image you are actually altering micro-contrast at the edge of image details. I always apply sharpening at the very end of the process, when one can best gauge how much to apply. You should also sharpen an image at the size at which you intend to print. This means that when you save your images you should save them unsharpened and sharpen just before you print.

When sharpening I almost always use a two-stage process: Unsharp Mask followed by the High Pass filter. If you select the Unsharp Mask from Filter>Sharpen>Unsharp Mask a dialogue box appears with a thumbnail of part of your image and three sliders namely: Amount, Radius and Threshhold. The Amount slider is essentially the

'volume' control. The Radius determines the number of pixels on either side of the edges in your image that will be affected during sharpening. Threshold determines how great the tonal differences between neighbouring pixels need to be before they are assumed to represent an 'edge'. As a general rule I set the Threshold to a low value of about 1 or 2 and begin with a low radius of between 1 and 3 pixels. (The choice depends on the dimensions of your image in pixels.) Then I gradually dial in the Amount and at the same time zoom in and out of the image. With practice you will soon gain an understanding of the use of this tool and of what is and what is not acceptable for your own image-making purposes. One golden rule I always adhere to is to select a small Radius setting and turn up the Amount as opposed to the other way around. Another quirk to my sharpening practice is never to sharpen a sky. I have never seen a sky either on a bright day or in heavy storm, displaying grain or accentuated noise and for this reason alone I make a selection of the image excluding the sky prior to sharpening.

When I am finished with using Unsharp Mask I create a duplicate layer (Ctrl J) which will make an identical copy excluding the sky. Then I choose Filter>Other>High Pass. At this point the screen (other than the sky) will turn grey and a dialogue box will appear once again showing a small thumbnail of part of the image and a single slider to set Radius. Zoom into your image and gradually dial in the Radius slider until you see the edges of your image appear through the grey. This is Photoshop seeking out the edges in your image and when you see the edges you wish to sharpen then click OK. At this point nothing will appear to happen but if you then go to the Blending Mode at the top of your Layers palette and change the blending mode to Hard Light the entire image will re-appear. If you then click on the Eye symbol next to your upper layer you will be able to switch the effects of the High Pass Filter on and off. This effect can be refined further by adjusting the Layer Opacity from the slider, also situated at the top of the Layers palette.

Other sharpening tools are available in Photoshop such as Smart Sharpen, which offers similar controls to Unsharp Mask with the added option of individual shadow and highlight sharpening. Lastly, it is worth considering that you can selectively sharpen any area of an image to any degree required using various selection tools and making a duplicate layer.

Printers I have tried several printers over the years and am now comfortably settled with the Epson Stylus Pro 7800 and the Epson Stylus Pro 3800 series, along with the the Epson K3 ink set and Epson Advanced Black and White (ABW) Driver.

A problem I have sometimes encountered in the past is that my prints seemed to be affected by a reduction of approximately 11% in print density and a 5-6% reduction in contrast when compared with the image on my monitor. This was easily resolved by applying adjustments in the Epson driver and saving the settings.

The ABW driver works by dropping the full cyan and full magenta from the mix of inks and then building the grey density from the remaining inks namely, Black, Light Black, Light Light Black, Light Magenta, Light Cyan and Yellow. This has two advantages: there are fewer strong colourants that might cause the tones to 'drift' away from pure colour-neutral and there is a reduced risk of any long-term fading of strong colourants which would cause a loss of density in the print, along with a colour shift away from neutral.

After setting the desired print output size in the Image>Image size menu, go to File>Page Setup (or File>Print with Preview in CS2) and set your paper size from the drop-down selection then set your source which can be sheet or roll depending on your media type. After this go to Printer>Properties and you will be presented with your printer main menu. Now you must select the media type that you have loaded in your printer. It is worth mentioning at this point that certain media types, if selected, will not allow you to move on to using the Advanced Black and White driver. Media such as Plain Paper-Matte Black, Plain Paper-Photoblack and Photo Quality Inkjet Paper will grey-out the driver in the Colour options below. After setting your media type click onto the Colour box and you will find the Advanced Black and White driver. If you then select Custom>Advanced you will see the driver. Here you will be faced with an array of controls such as Print Quality, Colour Toning, Tone and a small thumbnail image of a woman with a colour wheel below. My advice is to start with the following settings: have Colour Toning set to neutral and begin with Normal set from the Tone drop-down menu. Leave Brightness, Contrast, Shadow-Highlight etc in the list below on zero and have the Highlight Point Shift set to 'off'. I set the Print quality to SuperPhoto 2880dpi and uncheck all the boxes below for High Speed/Finest detail etc. Make a final check that your Media Type is set correctly then click OK in the advanced dialogue box, click OK in the printer main menu and click OK in the printer Page Setup menu. At this stage you will be back to your Photoshop CS3 Page Setup menu which you should click OK and then go to File>Print in Photoshop. This brings up the Print dialogue box where you must now remove the option of any colour management by selecting 'No Colour Management' in the Colour Handling drop-down menu. (This is in the Print with Preview box.) You will now see that the option for selecting Printer

Profile has been greyed-out so the printer is fully set up for using the ABW driver. I would recommend starting by taking one of your most familiar images and producing a print using these settings. If you then feel there need to be further adjustments, go back and gradually make them, following each with another print.

I have found that it takes only a short time to fine-tune your settings to produce exactly what you want in your print; when this point is reached simply save the setting at the bottom of the ABW dialogue box and name it. When you next open Photoshop and navigate to your main printer dialogue box select your media type once again, select ABW and when you click on Custom Settings your saved settings will appear in the drop-down list. If you are looking for a neutral image tone I would first begin by trying the Light, Dark or Darker settings in the Tone drop-down list, then move on to other adjustments such as Contrast and Brightness. If you wish to tone your images the pre-sets in Colour Toning will offer Cool, Warm and Sepia. Cool produces results similar to Agfa Brovia, which was a cold-tone bromide darkroom paper, Warm resembles Agfa Record Rapid, a chlorobromide darkroom paper and Sepia is similar to a thiocarbamide-toned silver halide darkroom paper.

Papers One of the most critical and personal stages in the making and presenting of photographs is choosing what paper to print the image onto. In today's market the choice is quite simply vast and one can get confused because of the subtle differences between the various papers on offer. With my current printers, the Epson Stylus Pro 7800 and the Epson Stylus Pro 3800, using the Epson K3 ink set, I choose heavyweight semi-gloss papers which give me results that are exactly what I wanted all along. My two current choices of paper out of the vast selection available are Epson Traditional Photo Paper, which is a 330 gsm gloss, and Permajet Fibre Base Gloss, which is a 295 gsm gloss. Both these papers have characteristics resembling those of darkroom papers and have a weight and finish that oozes quality and work wonderfully with Epson K3 inks.

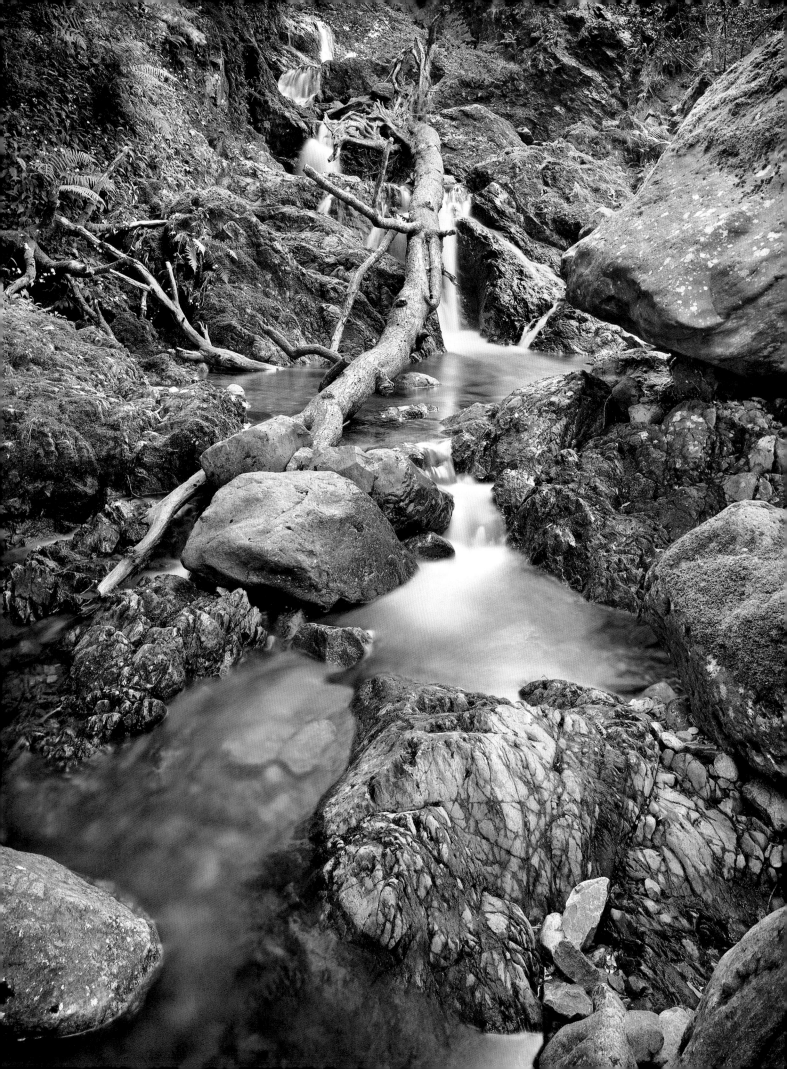

The images

Pine plantation Page 7

Walker Titan XL, 90mm lens, yellow filter, two neutral density non-graduated filters, 1.5 minutes at f22, Ilford Delta 100, processed in Tetenal Emofin.

Photography is used to convey visual information, but it can also convey a feeling for what the other senses would have experienced at the moment of exposure. This plantation of managed woodland contained trees of equal age, equidistant from each other, with a monoculture at their feet. Very unnatural. I recall being transfixed by the sound of the white, wispy grasses moving in the prevailing breeze, caressing the bark of the trees. As I could not see beyond the plantation I felt as if I was encapsulated within it, with no floor and no sky. The long exposure was intended to capture the stillness of the trees and bark detail and their relationship with the grasses and their movement.

Waterfall #3
Honister, Lake District
England

Page 26 **Barcaldine forest**

It was the dappled light that I was so keen to capture as it picked out small areas below the conifers and enhanced the texture of the tree bark. The composition was one that took a little consideration. I needed to convey two essential impressions in this photograph: the size of the trees and the light playing upon them. Between the three main trees there was a steady shaft of light that illuminated the forest floor and also lit the upper parts of the trees. My vision was of a soft range of muted greys with subtle shadows and critical fine detail. I fitted a 90mm lens and ensured the centre tree was vertical in centre frame and allowed the other two main trees to almost lean towards it. I waited for the breeze to subside and a moment of calm before making the exposure. The film was subjected to a two-bath process, to ensure no blocking up of the highlights.

Walker Titan XL, 90mm lens, yellow filter, 1 second at f22, Ilford Delta 100, processed in Tetenal Emofin.

Page 34 **Luskentyre**

In deserted places such as the Outer Hebrides one can become fully connected with the surrounding environment. This vast tract of almost white sand with clear waters opens up before you, simply inviting you to enter. On this day the weather was rapidly becoming inclement and after taking several photographs in good weather, I became quite intimidated by the driving winds. With little shelter I was exposed, yet tightly enclosed between the heavy skies and the whipped-up sand, facing head-on into the approaching storm. The repeating patterns in the sand seemed to echo the orientation of the clouds and the sky dominates the composition as a representation of the force of nature above.

Ebony 45SU, 90mm lens, orange filter, 1 second at f22, Ilford Delta 100, processed in Prescysol EF.

Page 38 **Skipness beach**

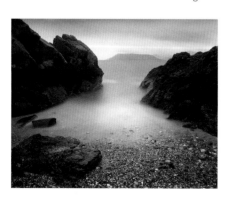

This is not actually a beach but a tiny inlet that can be accessed by scrambling on all fours. Although the light was flat I still felt compelled to make an exposure. This image quite accurately conveys my emotion at the time of exposure, when I was tired and very down-beat and, if I am to be honest, in rather a grump! As I stood and literally stared the one thing that captured me in the still air was the sound and movement of water as it pushed through the gap between the two bodies of rock and retreated again. The visualisation was instant; I fitted both of the neutral density uniform filters that I had to my lens and calculated the exposure to be one and a half minutes. I stood still and knew that the accumulation of time collected on film would reward me with a smooth body of water between the ominous black rocks on either side.

Ebony 45SU, 90mm lens, two neutral density filters, 1.5 minutes at f22, Ilford Delta 100, processed in Tetenal Emofin.

Winlatter Forest Page 42

Ebony 45SU, 90mm lens,
no filter, 1/4 second at f22,
Ilford Delta 100, processed
in Prescysol EF.

One of the benefits of monochrome film and its associated
developers is the control one can, with practice, exercise to
produce results that closely emulate what the human eye
can see. This is an example were close metering of values
and fastidious darkroom control rewarded me with an image
exactly as visualised. My eyes could see the delicate detail
in the shadows that almost glowed with the light reflected
from the forest floor, along with the jewel-like water from an
earlier downpour adorning the delicate shapes of the smaller
pine trees. The most expressive elements of this image are
the stillness and calm and the celebration of forest detail that
is often enclosed in shadow and dampness.

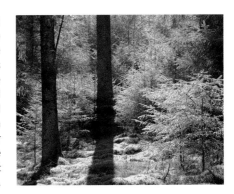

River Rawthey Page 48

Ebony 45SU, 72mm lens,
deep green filter, 1 second
at f22, Ilford Delta 100,
processed in Tetenal Emofin.

One of the advantages of visiting a new location is that you
have no preconceived ideas about what you ought to be
photographing, unless of course you have been influenced by
the work of another photographer. After much deliberation
about where to go on a spare day, I decided to venture into
the Yorkshire Dales National Park. First impressions left me
somewhat overwhelmed at the copious opportunities around
every corner. I decided to slow down and found myself alone
and free to become enveloped by the landscape. It was early
spring and the leaves were lime green and fresh.
I fitted a green filter to lighten the values of the new
leaf growth. After processing and scanning, very little
manipulation was needed and most of this was directed at
the area of the sky – a green filter may help with your green
foliage but does little for blue skies.

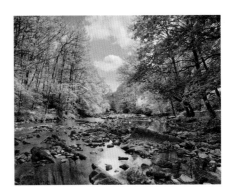

Ailsa Craig Page 53

Mamiya RB67, 90mm lens,
yellow filter, 1 second at f22,
Ilford Delta 100, processed
in Ilford LC29.

When considering how to give a monochrome image
emotional impact one should not automatically assume that
this involves making a 'heavy' print in order to introduce
'punch'. In this case printing 'heavily' or darkening globally
was considered at the moment of exposure. Ailsa Craig was
visible through the cloud and rain only at fleeting intervals.
These glimpses were, however, enough for me to form a
visualisation in my mind of what Ailsa Craig looked like.
Composing the image was simple and symmetrical and all I
had to do was wait for another break to bring the rock and
Ailsa Craig together through the rain and cloud, looking at
each other across the isolated beach and the sea.

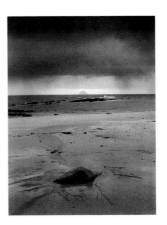

Page 54 **Abandoned croft**

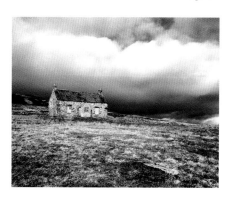

Buildings seldom feature in my images as I seek out what pleases me, which rarely involves people or their associations. This is, of course, foolish considering that all of our landscape has been modelled and fashioned by the hands of man. I was heading north and the light was harsh and burnished all it touched on this winter evening. As I walked up the track I felt a strange trepidation, almost as though I was intruding. I stood quietly in the bitter cold and looked up at the building standing above me, scarred and proud. I moved nearer and walked around it, imagining the door might open to reveal people, voices and life. The croft was in a poor state and as I moved back to my original position I knew this was right for my composition. The building looked down at me from its bleak setting while the Scottish weather threatened to envelope it, as it must have done so many times before.

Mamiya RB67, 90mm lens, yellow filter, 1/2 second at f22, Ilford Delta 100, processed in Perceptol.

Page 58 **Chapel Stile**

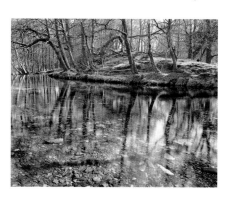

The light was crystal clear and the water was relatively shallow for winter, enabling you to see the stones beneath the surface. The bare trees on the far bank created a reflection in the water as they glistened in the light. The composition was to include no foreground, which would only be a distraction when I wanted the viewer to look into the water, at the reflections on its surface and downstream, and across towards the skeletal trees. As I stood there I felt a wonderful moment of calm looking at the stillness of the water, experiencing its silence before it reached the weir and enjoying the brilliance of the harsh winter light. This image, for me, encompasses light, emotion and visualisation in one.

Mamiya RB67, 90mm lens, yellow filter, 1/2 second at f22, Ilford Delta 100, processed in Perceptol.

Page 61 **Traigh Eais**

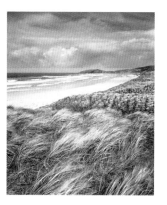

The remoteness of the landscapes in the Outer Hebrides is something to behold, especially when you are fortunate enough to have the weather you wished for. When I arrived at Traigh Eais after a short walk over the dunes I made several exposures close to the beach itself. But I soon found that the most alluring viewpoints were not on the vast expanse of sand but above, on the mature dunes. I was surrounded by a cool breeze that occasionally gave way to the warmth of the sun and by the 'wave-like' sound of Marram. The distant clouds were moving graciously over the headland and the sea swelled too and fro. I feel this image fully expresses my moment of emotional calm and the subtle greys represent me soaking into the peace of this place of exquisite beauty. Hardly any tonal manipulation was needed at all as it would have shattered my visualisation of what I saw and felt. The exposure was two seconds at f22 using a 90mm lens to capture some of the movement in the Marram grasses.

Ebony 45SU, 90mm lens, orange filter, 2 seconds at f22, Ilford Delta 100, processed in Prescysol EF

Cloudburst Page 70

Walker Titan XL, 90mm
lens, red filter, 1 second
at f22, Ilford Delta 100,
processed in Tetenal
Emofin.

In parts of the North West coast of Scotland peninsulas accessed by a single-track road can offer amazing adventures in almost total solitude. As elsewhere in Scotland, the weather changes rapidly and one can easily experience several climates in a matter of an hour, which is one of the overwhelming attractions of this stunning country. I was exploring the narrow track that hugs the cliffs leading to the Rudha Reidh lighthouse in Wester Ross, when clouds began to form over the sea, wind whipped up the surface of the water and shafts of strong sunlight fought their way through the blackness. In a moment of absolute certainty I knew I could make an image of this theatre of light in its elemental glory. I watched as the light travelled across the water, making an infinity of forms and patterns. I made several exposures but this one worked best. This is very much an image of light as a compositional tool.

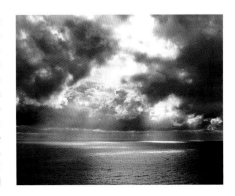

Waterfall #1 Page 74

Walker Titan XL, 90mm lens,
yellow filter, 1.5 minutes
at f22, Ilford Delta 100,
processed in Tetenal Emofin.

Waterfalls provide an opportunity to capture not simply a moment in time but the passing of time itself. On this occasion I was walking along the edge of a small series of waterfalls at the end of the Honister Pass in the Lake District when I happened upon the most exquisite arrangement of waterfalls I had ever seen. This particular waterfall was only about seven feet high and was enclosed in a steep-sided miniature gorge, into which light penetrated only from directly above. I made an instant emotional connection with the beauty of the single fall against the black rock and the small ferns as they tentatively reach outward to capture a little of the light from above. I knew that I had to retain the darkest shadow details and show the ferns emerging from the shadows, all within one long exposure, so that the wonder of the falls would be preserved as smooth as silk in the print.

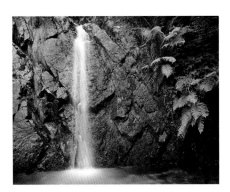

Buachaille Etive Mor Page 77

Walker Titan XL, 90mm lens,
red filter, 1 second at f22,
Ilford Delta 100, processed
in Tetenal Emofin.

Buachaille Etive Mor could be considered one of the most iconic mountains of the British Isles and when it is powdered in snow in February a wonderful three-dimensional texture is evident. When considering the composition, the mountain had to be central to the upper portions but not so overpowering as to detract from the other facets of the image. Waiting for cloud to break added to the intensity of the moment and the cascade of water and the movement in the trees shows the environment alive and kicking. This is not simply an image of a mountain but an image of an entire environment in winter with frozen ground, bare trees and ice-cold water. I made several exposures in the short period of time during which the light was gently caressing the side of the mountain from the left.

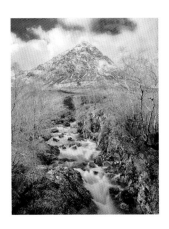

Page 80 **Sunrise, Arran**

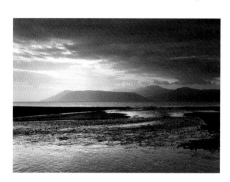

The drama of this image and the way in which it was printed can be directly attributed to my reaction to the light and my relief as the storm and heavy weather that had lasted several days began at last to clear. The night before this image was made I stayed in a fisherman's cottage on the very edge of the Kilbrannan Sound which separates the Kintyre Peninsular from the Isle of Arran, and several times I believed the roof was coming off! Early the following morning, after a fitful night's sleep, I awoke to a moment of calm and a change in conditions. As I made it to the tiny village of Skipness I was rewarded by a fantastic clearing storm and a burst of dawn sunlight that wonderfully illuminated the individual peninsulas of Arran and the craggy tops of Goat Fell. The rainfall filled the rivers that entered the Kilbrannan Sound which remained in shadow at the foot of the composition. The birth of fresh light on a new day.

Walker Titan XL, 90mm lens, yellow filter, 1 second at f22, Ilford Delta 100, processed in Tetenal Emofin.

Page 92 **Storm and tree**

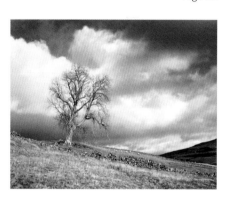

As a landscape photographer, I am without doubt obsessed with changing weather. I was walking in some of the rolling hills outside the small hamlet of Pitlochry and I happened upon an old tree, growing high upon a hill next to a derelict dry stone wall. I took the opportunity to stop and simply watch the clouds as they formed and reformed themselves over and over again. I soon became transfixed by the clouds behind it and set up my camera. As the clouds moved there was a glimpse of blue sky and a brief moment of winter sun illuminated the tree.

Walker Titan XL, 90mm lens, red filter, 1 second at f22, Ilford Delta 100, processed in Tetenal Emofin.

Page 97 **Kirkcudbright Bay**

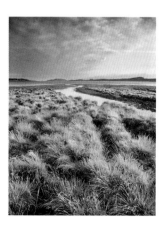

This area of the Borders of Scotland is what I call my new playground. Having visited it several times now, I have begun to fall in love with its simple but stunning coastline of sandy bays and the low, rolling hills behind. This is one of the inter-tidal zones which abound in the Borders and which are difficult to negotiate without ending up in mud up to your hips! The almost white grass was what first enticed me to set up the camera on the edge of the small river that ran out into the estuary. Soon after setting up I lost my evening sunlight to an imminent change in the weather that was fast approaching. However, having negotiated the mud and being perched on top of a tussock of grass, I was not willing to give the moment up. I could see that if I remained patient the looming cloud would contribute to the final image. As the bottom edge of the cloud intersected with the end of the river the composition was completed before my eyes.

Ebony 45SU, 90mm lens, yellow filter, 1/2 second at f32, Delta 100, processed in Ilford Perceptol.

Storm , Ullswater Page 101

Mamiya RB67, 90mm
lens, yellow filter, 1/2
second at f22, Ilford Delta
100, processed in Ilford
Perceptol.

I was camping close by the northern part of this lake and a
fine day was coming to a close as the Lakeland rain moved
in. I headed out in an attempt to catch this change and also
to make an image of a scene that is often shown as a pretty
boathouse set in a picturesque scene. The world of postcards
often depicts such places as sunny and bright, but all-too-
often they are not, which is why the place is full of lakes! I
set up my camera very close to the road next to a reed bed
that was being whipped by the approaching wind which
was carrying the rain. I simply waited until the last light just
picked off the wind-driven waves and made my exposure.

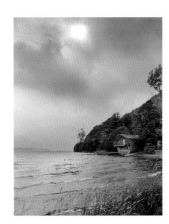

Storm, Killiecrankie Page 104

Mamiya RB67, 90mm lens,
yellow filter, 1/2 second
at f22, Ilford Delta 100,
processed in Tetenal Emofin.

When I set up the camera the whole scene was bathed
in clear, bright light. My intention had been to record the
brilliance of the light as it ran through the entire length of the
valley. Suddenly the wind picked up and a storm approached
at an alarming rate, with a shadow of heavy cloud rolling up
the valley towards me. I waited for the shadow to almost
engulf the trees in the middle distance and had time to make
just a single exposure before I packed up and headed for the
car – quick! Because the conditions changed so fast, I had
little time to consider what I hoped to convey, but I feel the
image captures my emotional response to the scene.

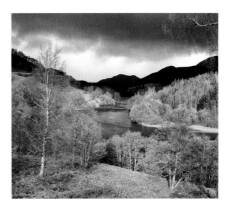

Slioch Page 107

Ebony 45SU, 90mm lens,
red filter, 1 second at f22,
Delta 100, processed in
Prescysol EF.

The grand mountain of Torridonian sandstone called Slioch
was standing snow-capped amidst a swath of moving cloud
and blue skies. It was late morning and the light was very
harsh. I knew that if I ventured across the boulder field
that runs along the southern banks of Loch Maree then I
would be rewarded with an elevated position from which to
photograph this awesome piece of geology. The composition
was simple and almost automatic to me. I wanted to show
the sheer scale of the mountain and place the viewer in the
landscape, looking across the boulder field towards Loch
Maree and upwards to Slioch. I waited some time for the
clouds surrounding Slioch to point in the direction of the
peak and to gently diffuse the light

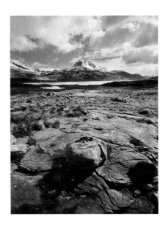

I would like to thank Michelle, my wife, for kindling the flame of photographic vision in me and leading me further along the path of self-discovery.

I would like to thank Pauline and Peter, my mother and father, who gave me my first camera and who have always set me free to explore all that I have become today.

Many thanks to Eddie Ephraums for trusting in me, giving me the opportunity to write this book and guiding me through a process I knew nothing about.

I would like to thank Joe Cornish who has always been on hand to offer advice and support throughout my emergence as a professional landscape photographer.

Many thanks to John Wardle who listened and gave me time as a young college student and who was the foundation of my photography.

Finally, many thanks to my close friend Mike McNamee of Colouraudit. com who has remained a constant source of information and advice about Photoshop and colour management throughout the writing of this book.